TABLE OF CONTENTS

FOREWORD

The mark of an intriguing book is the sense that no one but the author could have written it. Many people can write about the arts or education or give practical activities for art specialists to try, but this book carries the unmistakable stamp of the character, dedication and yes, genius, of its author. As Sofia's colleague these past 15 years at The San Francisco School and fellow teacher in many Orff Schulwerk courses worldwide, I can testify to all this first-hand. I've walked through her classes—with more than a touch of envy— and seen the children so happily and thoroughly engaged. I've listened to her describe things she's done in classrooms or workshops, seen her stop at stores to look at a toy or come out of bookstores with her arms full and ten new ideas in her mind. Many times I have encouraged Sofia to gather these ideas and put them between two covers—and much to the enrichment of teachers and the children they teach, she has done it.

One can only be in awe at the depth and breadth of the work presented here. It comes from her rich cultural roots, her thorough training both in Spain and at the Orff Institute in Salzburg, her tireless energy, relentless curiosity and incessant urge to keep exploring and trying out the unknown. She is one of the hardest workers I know, putting hours into planning a class that will give her children 40 minutes of pleasure. Why? The answer is simple—Sofia loves children. She also knows children, admires children, understands how they think and play and wraps her classes around their natural style of investigation.

And the children are everywhere in this book. Their artwork, their poetry, their dancing, their always-revealing and intriguing comments. This is no abstract treatise written in some remote office— each word, each idea, has paid the dues of thousands of hours spent on the floor with the children, playing with them side-by-side and noticing their reactions, their ideas, their thoughts, their boundless imaginative responses.

If you're looking for pre-programmed activities designed to achieve pre-programmed results, close this book now. In this collection of activities, Sofia asks you to think, to observe, to consider the models presented here and translate them into your own way of thinking, your own way of relating to the children. There is plenty of practical information to help you on your way to doing that—great rhymes, specific art projects, beautiful music playable by children, fun and imaginative games. By bringing them to life in your classroom, you can help restore the torn fabric of education to its full and luminous beauty.

—Doug Goodkin

PREFACE

I was a young teacher when I experienced a turning point in my career. During a rehearsal with my percussion group, I observed a student rolling a maraca back and forth on the floor. While the rest of the players were performing a rhythmic ostinato perfectly, this child seemed to be in his own world. "What are you doing?" I asked impatiently. "Listen," he said, "The sound of the waves in the ocean." The rolling motion of his maraca produced a sinuous crescendo and decrescendo. Inspired by his idea, I asked all the maraca players to roll their instruments on the floor like that—the effect was brilliant!

Some years later, I had a similar experience. After a movement class, Alejandra, four years old, gave me a drawing of a girl dancing (below). You can see she concentrated mostly on the skirt, that being the most exciting part of her twirling. I asked her why she drew 2 red stripes, 2 brown, 2 pink and only one orange. Her huge eyes stared up at me, as if to say "Don't you get it?" She then patiently explained, "The other orange stripe is on her back. Do you see how she is turning?"

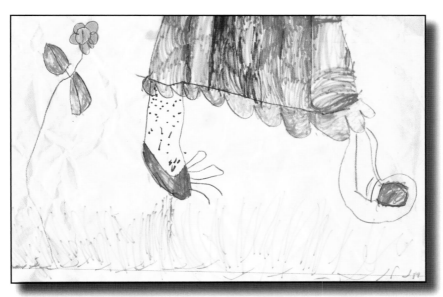

Alejandra, 4 years old (1989)

Those children, and countless others, taught me my most important lessons as a teacher:

- Observe how the children are thinking and ask what they're thinking.
- Watch how they react.
- Accept their response and try out their ideas.
 Once you understand that children indeed have interesting, and often, brilliant ideas, your teaching will change.

Why a book about music and art?

In Ancient Greece, poetry, music, dance and visual arts were core values of the culture—thus, cultivating the body, the mind and the spirit was the ultimate goal of education. We seem to have lost that unity in our schooling. This was on my mind when my mentor teacher, Elisa Roche, planted the seed that would grow into this book. We were looking at a children's art project and discussing how art and music have more in common than most people think. After our meeting, I dreamt of pages filled with music and dance ideas, artwork and poetry by children in a successful marriage of visual and performing arts.

Wassily Kandinsky, a seminal figure in modern art and an astute commentator put it this way: "The arts are encroaching one upon another, and from a proper use of this encroachment will rise the art that is truly monumental."[*]

Visual and performing arts affect our emotions and our senses. We can be moved by a piece of music or art by simply listening or looking. When we ourselves perform or create, it affects us in a different way. In my classes with the children, we both perceive and express each art form separately and also combine them to discover their common elements. Music is the art of thinking with sounds organized in rhythms, melodies, harmonies, texture, forms, and timbre. Art has similar elements of color, form, design and texture while dance and language have parameters in common with music and art. Experiencing a single concept through multiple art forms makes a profound impact on learning and the class becomes an exciting adventure.

In these pages I am collecting some of the didactic experiences from my classes over the past 30 years combining music, poetry, dance and visual arts in an interdisciplinary manner. Interdisciplinary learning refers to the interaction of ideas, and the awareness of connections between disciplines. These ideas have been developed with students from three to thirteen years old and the context of this research is the Orff Schulwerk music and movement classroom.

Orff Schulwerk

Composer Carl Orff (1895–1982) and his collaborator Gunild Keetman (1904–1991) developed a holistic educational concept (now known as Orff Schulwerk) whereby students learn through active music-making. Schulwerk (German for school work) as a pedagogy and a philosophy connects the emotional and cognitive aspects of learning and puts the child at the center. Orff described it as, "A music exclusively for children that could be played, sung and danced by them, but that could be also in a similar way invented by them—a world of their own."

Orff Schulwerk teachers give importance to the pathway we follow to educate the child, to the way we reach the emotional and cognitive aspects of music learning. That is precisely what makes this teaching style an interesting pedagogy. The ancient Greek roots of the word pedagogy, "παιδ" (paid) child and "ἄγω" (ágō) lead, can be translated literally as "to lead the child". The Latin derived word pedagogy refers to the entire content of education, strategies and style of instruction. But, what is special about Orff Schulwerk Pedagogy?

Traditional methods of teaching music often start by focusing on the technical steps of instrumental playing and on the music literacy needed to read the score, as if this was the only way of decoding and understanding musical language. In Orff Schulwerk we start with what children do best—chant, play, sing and move. Through creating, improvising, exploring and experimenting, the children arrive at a deeper understanding of music. Adding movement, drama and the visual arts makes the learning experience even richer.

[*] Lindsay, Kenneth C., Vergo, Peter. Kandinsky: Complete Writings on Art. Da Capo Press (1994)

In these lessons you will see how a poem might inspire a drawing, a dance might lead to a collage or a Miró painting might become a drumming piece. In this way, the children experience concepts from inside out and outside in—they become adept at making communal music and dance.

In Orff Schulwerk, teachers are not bound to use the same curriculum: we prefer to describe our work in terms of "ideas" and "processes" instead of as a method. As Carl Orff said:

> "Those who look for a method or a ready-made system are rather uncomfortable with the Schulwerk; people with artistic temperament and a flair for improvisation are fascinated by it. They are stimulated by the possibilities inherent in a work which is never quite finished, in flux, constantly developing."*

Though the students' creative response is unpredictable, the way teachers structure the class should be well thought out to spark the imagination, stimulate a variety of intelligences and provide learning opportunities for all students. The Orff Schulwerk is a way of discovering one's self through music-making and dance. This is true for both naturally talented students and those less inclined to sing, dance or play an instrument. The greatest pleasure I derive from working with Orff Schulwerk, is in the diverse array of ideas and expressive media that provide possibilities for *everyone*.

How to use this book

In these pages you will find ideas, suggestions, exercises and open experiments. As Orff suggests, they can serve as the starting point of your own investigations. As the teacher, you should be able to:

- Not only reproduce the ideas, but also re-create them.
- Organize the lesson according to a particular situation.
- Decide the age-group for the projects and adapt as necessary.
- Find larger curriculum themes that can be developed following the models presented here.
- Look for other music, dance or art materials to create a new unit or theme.
- Lead composition and choreography projects based on new materials.
- Bring your own personality to the projects.

All exercises are subject to interpretation, as there are many ways to approach the educational experience. You can choose how to organize the class outline by applying different beginnings for each theme and various pathways to follow. You are invited to add and experiment, ignore or create a variation. I recommend documenting the learning process by observing and listening to the students as they work—take notes!

* Orff, Carl. The Schulwerk: Its Origins and Aims. Translated by Arnold Walter. Music Educators Journal. Vol. 49.

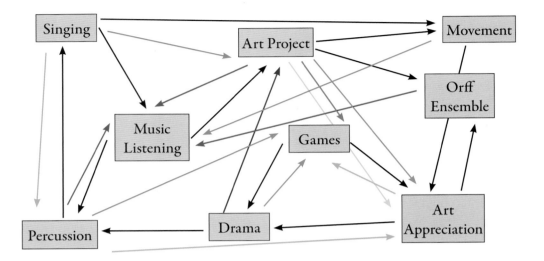

As the activities are presented thematically rather than sequentially, think of them as resources to enrich and stimulate your program. As you see in the chart above, you can choose your own pathway organizing the activities—one time you start with a drama game, followed by a percussion piece and end with a music appreciation exercise and another time you do the exact opposite.

Who can use this book?

The ideas presented here can by used by Orff practitioners, art specialists and general classroom teachers. The visual art projects for example, can be used in a music class as a way to introduce a theme or end a session, while most of the songs, rhymes and dance activities are simple enough to be led by a non-music instructor. In this book you will also find different models of collaboration with your fellow teachers, researching, planning projects and sharing ideas.

The activities in these pages intend to develop intuition, observing skills, sensorial experiences and inner-growth. My students are masters at exercising those skills and you will find their inspired ideas on every page of this book.

ACKNOWLEDGEMENTS

The pages of this book, filled with children's art, music and poetry, reflect the hands and hearts of wonderful teachers in three different corners of the world. The schools represented here constitute an important part of my life and my teaching career, not only as a teacher and a pedagogue, but also as a human being. I'm indebted to the following schools and many of the inspired teachers who work there. Thanks to:

THE SAN FRANCISCO SCHOOL (SAN FRANCISCO, CALIFORNIA)

The San Francisco School, where I have worked these past 15 years, is an independent school founded in 1966. It began as a Montessori preschool and grew to include elementary and middle school programs that integrate an eclectic blend of educational practices. The San Francisco School has long had a strong commitment to the arts. All the children go to classes taught by specialists in music, visual arts and drama, as well as work creatively in their classroom. The Orff Schulwerk program has achieved international recognition and it has been a pleasure to develop it alongside my colleagues Doug Goodkin and James Harding, who inspire me on a daily basis. Thanks also to art teachers Karen Goodkin, Mia Morrill and Nova Ray, for their beautiful work on some of the projects herein and to teachers, Laura Burges and Molly Treadway, for their classroom work in poetry and rhyme illustration.

JITTAMETT KINDERGARTEN (BANGKOK, THAILAND)

Founded and directed by Krontong Boonprakong, the school has one of the most beautiful environments I have ever seen. The children at Jittamett breathe an artistic environment from the moment they step through the gate. The play and workspaces are specifically designed to give the students a multi-sensorial aesthetic experience. The teaching staff is trained in Orff Schulwerk and the general curriculum is inspired by Montessori, Reggio Emilia and Project Zero ideas. I have visited the school several times and conducted workshops for the staff on music, dance and visual arts. Many thanks to music teachers Sataporn Laithong and Krontong Boonprakong and art teacher Warangkana Siripachote.

PEDRIATRIC ONCOLOGY DEPARTMENT HOSPITAL MONTEPRÍNCIPE (MADRID, SPAIN)

Directed by my sister, Dr. Blanca López-Ibor and Dr. Marta Villa, this children's hospital offers a wonderful infrastructure to make the lives of the children undergoing cancer treatment as normal and easy as it can be. The hospital adapts to the child, not the child to the hospital. The doctors, nurses, psychologist, music therapist, spiritual counselor, and volunteers work as a team and support the child and the family throughout the treatment. Many thanks to music therapist Camino Bengoechea, whose relentless commitment and dedication to the artistic development of the children in the hospital is admirable. Thanks to my sister Blanca, for letting the children stand at the center of the program.

SPANISH PUBLIC SCHOOLS

Public Schools in Spain offer a combination of music, drama and visual arts as part of the Artistic Education curriculum. There are many wonderful Orff-Schulwerk pedagogues committed to public school education in my country and I wanted their work to be represented here. Thanks to Marga Aroca and the students from Colegio Público La Navata, (Galapagar-Madrid), who collaborate here with their illustrations of La Vaca Estudiosa. Thanks to Juana Fernández, and the students of Colegio Público La Dehesa del Príncipe (Cuatro Vientos- Madrid), who worked on the cubist project for *Blue is the Sea*.

I also want to express my gratitude to the teachers who have contributed songs and musical materials to the book. Li Cao for her Chinese song about the chicken, James Harding for his recorder arrangement of the Cuckoo song and Wolfgang Hartman and Fernando Palacios for their wonderful

graphic scores. Most of the photographs in the book are taken by Krontong Boonprakong and myself, but thanks to Mark Johann and Patrick Fahey for additional photos.

Thanks to Leah Sandler (3rd grade) for the cover art, to Peter Nam for his inspired graphic design and to Bill Holab for layout. Thanks to Doug Goodkin for checking the scores and commenting on the text, to Dan Kluger, who helped shape this work in its beginning stages, to Peter Greenwood, who edited it in its final stages and to Corrine Olague for proofing the final copy. A final thanks to Pentatonic Press, for enthusiastically receiving this work.

MUSIC, MOVEMENT AND ART

BUTTERFLIES AND CATERPILLARS

One day during recess I was especially attentive to a young student on his first day of school. Samuel was the only 3-year old in the playground and he spent his morning checking things out with his eyes wide open. A white butterfly crossed the air and landed in a rosemary bush next to us. "Look," he said, "a butterfly!" He just stared at the insect, somehow knowing that this moment wouldn't last long. I didn't dare interrupt that magic moment. When the butterfly was gone I asked him, "Why do you like butterflies?" "They are pretty and soft. If you try to grab them you can break their wings." Butterflies are one of the most diverse type of insects and are attractive not only to the entomologist who studies them but to children young and old. Delicate and dynamic, butterflies can inspire us to compose poems and music, to sing and to move.

"La mariposa en la cocina" is a Spanish chant and clapping game with various versions throughout Latin America. The butterfly here is personified as a generous character, making delicious chocolate to share with her neighbors.

Avery, 4 years old

I also use butterflies for teaching poetry composition. I start the session with "The Butterfly Alphabet," a poster by the naturalist and photographer Kjell Sandved, and other books that show details of insects: proboscis, wings, antennae, etc. We observe the combination of colors and the symmetry in the wings and details of the patterns. The students get a printed copy of the 'Butterfly Alphabet" letters to compose an acrostic poem that will be set into music and movement.*

* Sandved, Kjell Block. The Butterfly Alphabet.

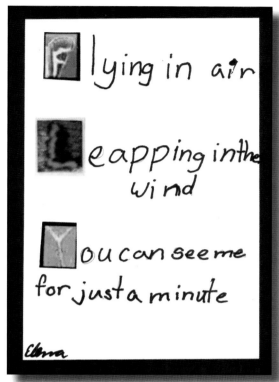

Flying in air

Leapping inthe wind

You can see me
for just a minute

Elena, 9 years old

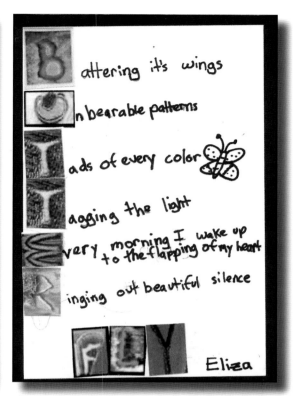

Battering it's wings

Unbearable patterns

Fads of every color

Tagging the light

Every morning I wake up
to the flapping of my heart

Singing out beautiful silence

FLY

Eliza, 9 years old

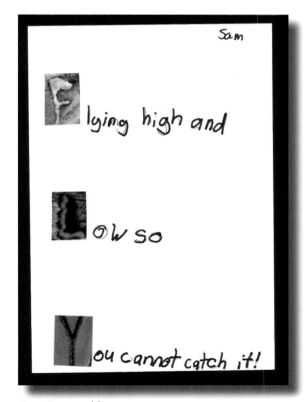

Sam

Flying high and

Low so

You cannot catch it!

Sam, 9 years old

LA MARIPOSA

Peruvian Rhyme
arranged by Sofía López-Ibor

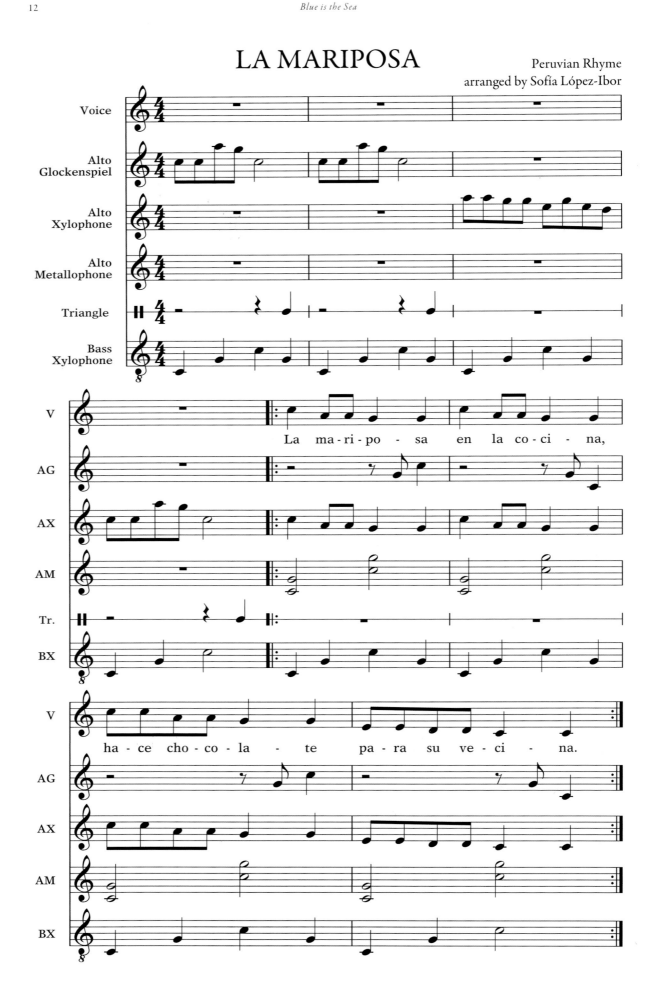

MOVEMENT

To increase body awareness invite the students to move like a butterfly. Explore the following qualities of movement:

- Light
- Soft
- Smooth
- Lively
- Flowing

MOVEMENT GAME

Participants divide in 2 groups, one moving, the other observing. Observers think of interesting ways to make the butterflies move.

- Nervous butterfly
- Wet butterfly
- Circling butterfly
- From caterpillar to butterfly
- Butterfly inside a box

SINGING

La mariposa en la cocina,
Hace chocolate para su vecina.

Translation:
The butterfly in the kitchen Makes chocolate for her neighbor.

Students sing while indicating the pitch with hand gestures.

CLAPPING GAME

Pair the students for learning this clapping pattern to accompany "la mariposa"

K-Cl-R-Cl-L-CL-F

K Knee
Cl Clap
R right hand with partner
L left hand with partner
F (front) both hands with partner

SPEECH

Add a chant to the piece describing the playdough butterflies
 Mariposa verde
 Mariposa roja
 Mariposa amarilla
 Mariposa blanca
 Mariposa grande
 Mariposa chica
 Mariposa chiquitita
 Mariposa azul

ORFF ENSEMBLE

La Mariposa
Music focus: Do pentatonic.
Form AAAB

- Start song with the Bordun accompaniment.
- Ask the students to figure out the melody.
- Add introduction and color parts for glockenspiel and triangle.
- Add an improvisation section using tremolos on one pitch, glissandi and sudden stops.

READING

The focus in this exercise is to read and track the beat.

 Use the butterflies as a music score. The students clap and say the rhythms.

- Change order, create a new rhythm
- Make some butterfly leave the score (rest)
- Interpret the chant with dynamics, crescendo and decrescendo

MOVEMENT

The focus of this game is balancing using the play dough butterfly as a prop (art project).

- Explore path & pathways and stillness.
- Balance the paper plate with the butterfly on different parts of your body.
- Move with smooth steps while exploring the space around you.

RELAXATION

(Using the playdough butterfly as a prop)

Ask the students to sit down with a partner. When the room is quiet, one person closes their eyes.

 The other lays the paper plate with playdough butterfly on some body part.

 The person with the eyes closed needs to whisper where it is (on my shoulder...)
 Switch roles.

SPEECH

Caterpillar caterpillar
Wriggle wriggle
Through the grass
You go so slow
Because you can't go fast.

- Have the students say the rhyme while patting the beat.
- Make a long fermata on the word slow.
- Make speech ostinati to accompany the text, e.g. ¨wriggle wriggle slow"

MOVEMENT

Represent the metamorphosis from the egg to the flying butterfly.
- The caterpillar pops out of an egg.
- Explores the world crawling around a stone, up a blade of grass, etc.
- The caterpillar makes a cocoon.
- Slowly emerges from cocoon and turns into a butterfly.

NOTATION

Notation games with short lengths of yarn.

- Make a caterpillar with the yarn on the floor and sing the melodic pattern- rising pitch, descending pitch, staying on one note, etc...
- As above, but represent the form of the pattern with a full body figure.

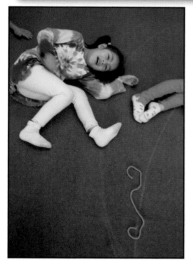
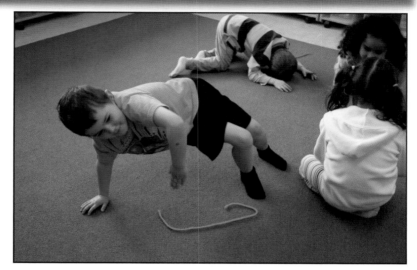

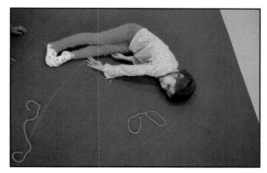

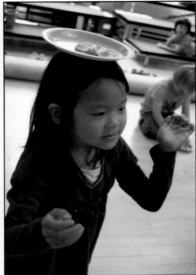

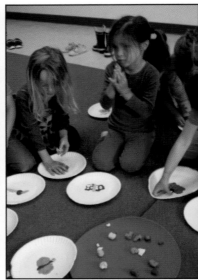

PLAY DOUGH RELIEF-BUTTERFLY

- Have students observe butterfly photos of good quality so that they can see the fine patterns and designs on the wings.
- Make a butterfly with play dough on a paper plate.

RECIPE FOR PLAY DOUGH

2 cups of plain flour
4 tablespoons of cream of tartar
2 tablespoons of cooking oil
1 cup of salt
2 cups of boiling water
food coloring

Mix in a bowl and knead.

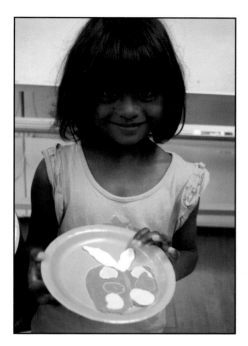

TISSUE PAPER COLLAGE—CATERPILLARS AND BUTTERFLIES

Read the book *The Very Hungry Caterpillar* by Eric Carle. Show photographs of caterpillars.

- Students cut circles of tissue paper to make the body shape of the caterpillar by overlapping colors.
- Add head, antennas and other details with markers.
- Use the same technique to make butterflies.

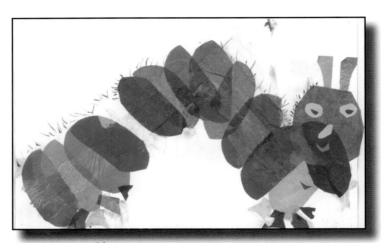

Emma, 5 years old

Sofia, 4 years old

Cole, 5 years old

FINGER PRINTS—CATERPILLAR

- Use your thumbs and fingers to make the body of the caterpillar by alternating colors.
- Add legs, antennas and other details with a thin brush.

Alex, 4 years old Isa, 3 years old Sean, 5 years old

Suggested Children's books

Horácek, Petr. *Butterfly Butterfly. A Book of Colors.* Cambridge, Massachusetts: 2007.
Kindersley, Dorling. *Eyewitness Butterfly & Moth.* London: DK. 2000.
Carley, Eric. *The Very Hungry Caterpillar.* New York: Philomel Books. 1969.
Fleming, Denise. *In The Tall, Tall Grass.* New York: Henry Holt and Co. 1991.

TWO LITTLE BLUEBIRDS

Children who grow up playing hand games become in tune with their bodies. Adults sometimes overlook the importance of playful activities that develop bilateral coordination and crossing the midline. Children also learn how to identify the fingers and know left from right with these games. Music teachers know how difficult it is to find a good rhyme, one that you want to do over and over again. Rhymes with a clear dual structure, like "Two Little Bluebirds" inspire many variations that help develop the fine musical and rhythmic tuning of the child. For example, we can ask the students to interpret the "Peter" and "Paul" part in the rhyme with contrasting high and low voices. This will not only refine their recognition of the form, but will develop the quality of expression in their voice. And after exploring this pitch quality, who is thinking of the next possibility? The children, of course.

"The instructions of the teacher consist merely in a hint, a touch—enough to start the child. The rest develops of itself" (Maria Montessori)[*]

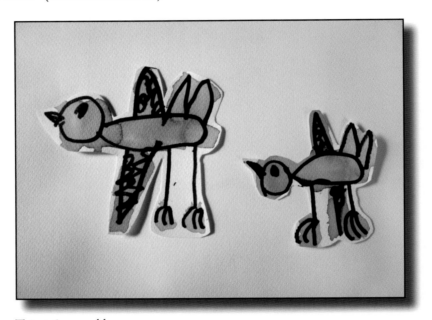

Thirat, 5 years old

This familiar hand rhyme has many variations, and exists in many languages. Some people play by showing and hiding the fingers behind the back, some use a full hand gesture and others paint little eyes on their finger to look like a bird. Young children are always enchanted by how birds fly away and then come back.

	A Variation:
Two little bluebirds	Two little blackbirds
Sitting on a wall	Sitting on a hill
One named Peter	One named Jack
One named Paul	One named Jill
Fly away Peter	Fly away Jack
Fly away Paul	Fly away Jill
Come back Peter	Come back Jack
Come back Paul	Come back Jill

[*] Montessori, Maria. *Dr. Montessori's Own Book*. New York: Dover, 2005

FINGER GAME
Two Little Bluebirds
- Make a wall with your hands, hiding thumbs.
- On "Peter" right thumb pops up, standing on the wall. On ¨Paul¨ left thumb does the same.
- On "fly away Peter" right hand goes behind the back. On "fly away Paul" left hand does the same.
- On "Come back Peter" right hand returns to the wall shape with the thumb upright. On "Come back Paul" left hands does the same.
- Both thumbs hide when the rhyme is over.
- Play the game with a partner combining 2 hands. One person plays with the left and the other with the right.

LANGUAGE
Two Little Bluebirds
Perform each part of the rhyme with contrasting characters:
- High/ low
- Loud/soft
- Fast/slow
- Happy/sad
- Young/old
- 2 instruments

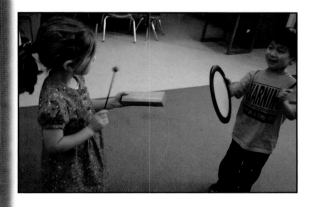

MOVEMENT
Two Little Bluebirds

- Two children representing Peter and Paul stand together in a "nest" or "wall" (hula-hoop, chairs…). They fly in and out according to the text. In their adventure:
- They have to touch a particular piece of furniture in the room, or a particular color…
- One flies fast and the other slow
- They fly to the same place in the room

LANGUAGE
Two Little Bluebirds

Variation—Create different text on the same idea.

2 little fishies swimming in a pond
 One named Pling
 One name Plong
 Jump up Pling
 Jump up Plong
 Dive in Pling
 Dive in Plong

BLUEBIRD

ENGLAND

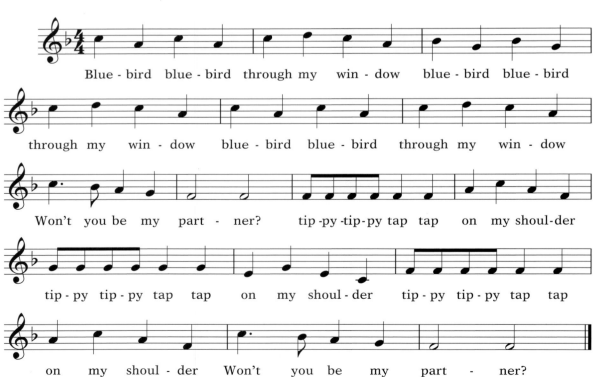

Blue-bird blue-bird through my win-dow blue-bird blue-bird

through my win-dow blue-bird blue-bird through my win-dow

Won't you be my part-ner? tip-py-tip-py tap tap on my shoul-der

tip-py tip-py tap tap on my shoul-der tip-py tip-py tap tap

on my shoul-der Won't you be my part-ner?

PLAY-PARTY GAME
Bluebird Bluebird

Participants form a circle and hold hands raising their arms up and forming arches.

- All sing while one person, the "bluebird," flies in and out the window.
- In the "tippy tippy tap tap" part she/he stops behind someone and pats that rhythm on his or her shoulders.
- At the end, the person chosen becomes the new "bluebird."
- Variation: The bluebirds can join in a line instead of going back into the circle, making the game cumulative.

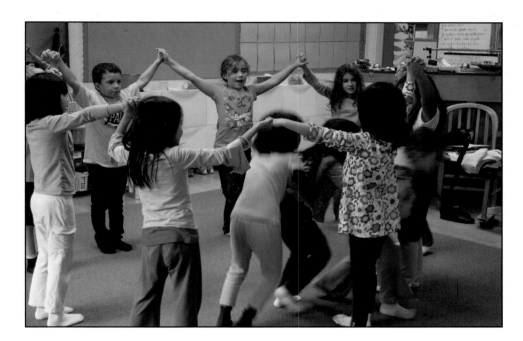

Carmen, 5 years old

TRIPTYCH: ACRYLIC PAINT

Have students work with the paper in a horizontal position. Paint a wall (a hill, etc) along the bottom part of the paper and sky above.

When the painting is dry fold the left and right side in and reproduce the wall outside.

Paint the birds on the wall.

This art project can be used as a score.

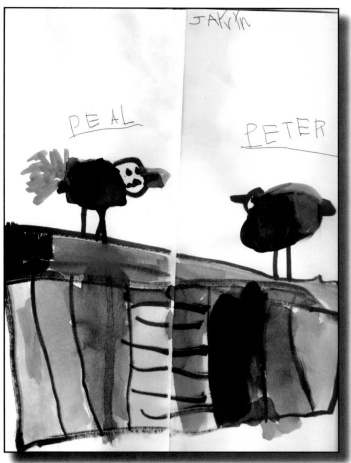

Javyn, 5 years old

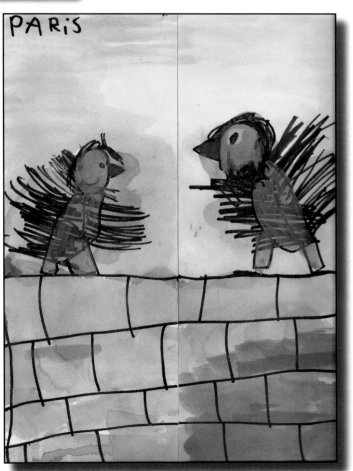

Paris, 5 years old

ENVIRONMENTAL ART

- Collect stones, small sticks, leaves or any natural material
- Place the materials on paper to make the birds.
- Photograph the construction

Plearn, 4 years old

Napat, 5 years old

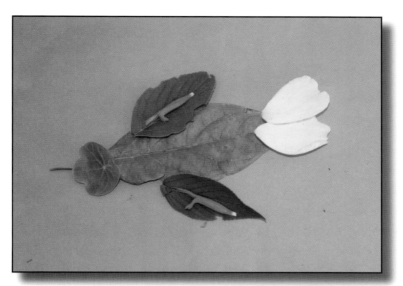

Isabella, 7 years old

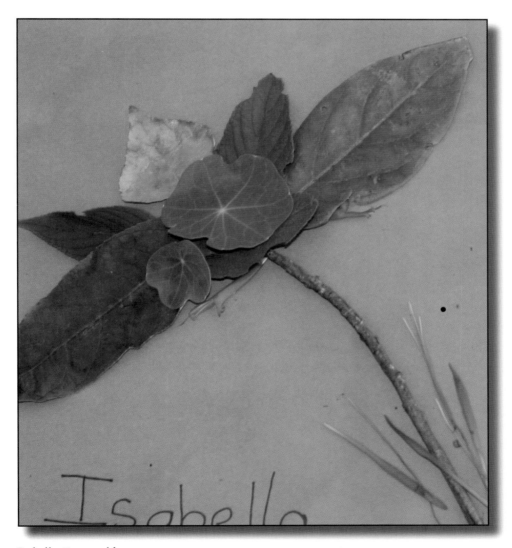

Isabella, 7 years old

PAINTING BIRDS

Walking down the hallways of schools around the world and watching students' art exhibits, I am always amazed by the display of creativity and imagination of children's art. The children fulfilling their need for expression show us their rich world of images and ideas. There is something very intriguing about the attempt to reflect the reality, the playful vision of shapes and colors and fresh texture and composition. Adults might have a sense of beauty that can be very different than the children's. When creating a work of art, students bring an experience and reveal something about themselves. As an educator, I am most interested in the process children go through to discover their own truth. They constantly impress me when I ask them to describe their art.

I know a parent who was furious when his child received a low grade in Art class. The task given by the teacher was to make a little yellow bird as a collage project. The very traditional teacher organized the project by giving all the students in the class the exact same size oval for the body and a small circle for the head. All they had to do was add a beak, a tail, one eye and two legs. Something like this:

The student in question changed the position of the beak, the head, and the legs:

The teacher interpretation was that the project was messy, the student was unable to make an exact copy of model, the student was disorganized and he even lost the little section of the tail. The father was surprised that the student never got a chance to express his own truth: "the bird is looking in a different direction." The student was not only ever asked, but the teacher was not allowing him to make a mistake. The child in question was not allowed to take the necessary risk of any creative process. He had to repeat the project and he felt ridiculed in front of his peers.

Imagine the same little bird assignment presented to the students like this:

- What color do you want your bird to be?
- Is your bird big or small?
- Have you noticed how some animals of the same kind have bigger and smaller bodies or heads?
- What is the bird doing?
- What is the bird looking at?
- Where is the bird?
- Is the bird facing back, front, sideways?
- Are you looking at the bird from above, from the side?
- What about the wings? Are they open or closed?

- Does your bird have long or short legs?
- Is the bird sitting? Balancing on one leg?
- Walking? Flying?

This story is, of course, an exaggeration of how teachers can sometime miss the opportunity to see children think creatively. And every person is creative. We just need to find ways to invite brainstorming and promote imaginative thinking and problem solving. The same issue arises when we talk about artistic expression and perception. Can you imagine all visitors to a museum reacting equally to a piece of art? As Albert Einstein says:

> "Imagination is more important than knowledge. For while knowledge defines all we currently know and understand, imagination points to all we might yet discover and create."

When it comes to perception or appreciation there are no wrong or right answers, in fact it is interesting to see the individual responses. The same should be in a creative class environment.

Suggested Children's books

Henkes, Kevin. Dronzek, Laura. *Birds*. New York: Greenwillow Books. 2009.
Lionni, Leo. *Inch by Inch*. New York: Harper Collins. 1960.
Burnie, David. *Eyewitness Bird*. London: DK. 2004.

BEES

While "The Ants Go Marching" and the "Eentsy Weentsy Spider" goes up the water spout, the "Ladybug" flies back home looking for her family. But of all the insects in the universe of children's songs and rhymes, it's surely the bee that has the most fascinating life.

- Bees dance: when a scout bee finds nectar in a flower, he performs a dance to tell the other bees where it is. The figures the bee dances mean different things—a circle indicates that the nectar is near the beehive while a figure eight means it is far away. The bee wiggles its belly for a short or long time to indicate the distance.
- Bees make music: their buzz has an interesting musical quality as composer Rimsky Korsakov demonstrates in his famous "Flight of the Bumblebee."
- Bees work hard: they have a complex process of transporting and storing the nectar for later use.
- We admire bees as sculptors and builders: they produce wax with a special gland in their bodies and use their mouth to model the hexagonal honeycomb.
- Bees have a complex cast society: a queen with a cohort of helpers that clean and feed her (male bees called drones).

Working with fragments or small compositional ideas is a common practice among Orff-Schulwerk teachers—we often let the children find a melodic pattern that naturally fits the rhythm of a text and then we start combining small ideas to form a whole song. Many children use formulas they have heard or played in other songs, while others simply find the pattern by chance on the xylophone. Developing a sense of how the intervals work in the scale is a more advanced concept. This lesson features a children's rhyme with a melody by Kealey McKown, composed when she was 5 years old. As I was helping the children understand how a melodic pattern can have an ascending or descending direction, she told me she could "hear" the bee jumping up the scale and then down. She could sing the melody clearly, pointing in the air, and she could play it on the xylophone.

The second musical piece presented here is Fiddle Dee Dee, a traditional chant telling us the love story of a fly and a bumblebee. There are a number of melodies associated with this rhyme, but I decided to perform it as a chant with the kindergarten students. I also used graphic notation to outline the rising and descending patterns, buzzing tremolos and other interesting effects and designs.

The last song here delights preschool kids, especially combined with the count-out rhyme:
Bumblebee, bumblebee,
Stung a man upon his knee
Stung a pig upon his snout
You are out!

STORYTELLING

The Fly and the Humblebee—Framing the rhyme with a story

Once upon a time there was a fly, who found the most beautiful, shiny, red stone in the world. With a lot of effort Fly picked up the stone and noticed it was heart-shaped. "That would make a wonderful Valentine for my love" she thought. Fly felt a need to love someone like she hadn't loved anyone else in the world. Fly started flying around looking for the object of her love, holding the red heart with her thin legs.

Fly found an old grey mouse: "Do you love me?" she asked. "No," mouse said, "In fact, get away from me! I hate the sound you make."

Fly found a big brown cow: "Do you love me?" "Love you? Can't you see all the effort I have to make to hit you with my tail?"

Fly found a fat, purple toad: "Do you love me?" "Of course I love to ...eat you!" Fly barely escaped when the toad stuck his long tongue out.

Fly heard an interesting sound. Hairy Humblebee passed by drawing beautiful patterns in the air, flying up and down, spiraling, zigzagging and making skillful turns. "Do you love me?" "You are kind of small and weaker than me, but if you can follow me around I would love you forever."

And so Fly did. She followed him up and down, spiraling, zigzagging and skillfully turning. After weeks of having fun together Fly gave Humblebee her red stone heart.

She felt unusually happy.

NOTATION

The Fly and the Humblebee

Imagine the fly is following the bumblebee.

Draw the pathways he makes as a map for the fly to follow.

Use them as a graphic notation to explore vocal sounds.

Teacher plays one of the maps and children identify it.

SPEECH

The Fly and the Bumblebee

Play a *gallop* 6/8 rhythm patting on the knees to accompany the rhyme

Students learn the text by chanting the refrain.

Fiddle dee dee, fiddle dee dee,
The fly has married the humblebee.
The humblebee was never so glad,
As when he had met with such pretty a lad.
Fiddle dee dee, fiddle dee dee,
The fly has married the humblebee.
They went to the church
And married was she.
The fly has married the humblebee.
Fiddle dee dee, fiddle dee dee,
The fly has married the humblebee.

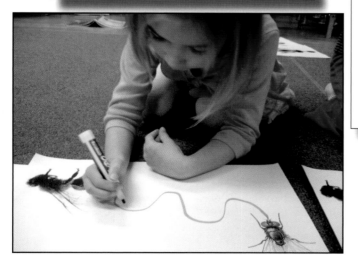

BEES MAKE HONEY

English Rhyme
Melody: Kealey McKown

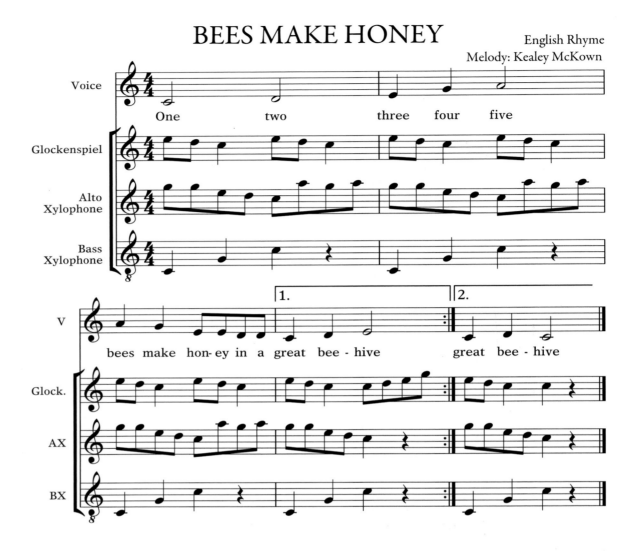

One two three four five

bees make hon- ey in a great bee - hive great bee - hive

ORFF ENSEMBLE

Bees Make Honey
Have the students sing the song while teacher plays the bass xylophone. At the end of the song children can add an improvised section in C pentatonic.

MOVEMENT GAME

Bees Make Honey

Students each have an apiary or assigned place. They sing the song and then "fly" out of their apiary while the teacher improvises on a recorder. When the recorder music ends they need to be back home. Every time they leave the apiary they follow a particular floor pattern.

THE BUMBLEBEE

German Folk Song

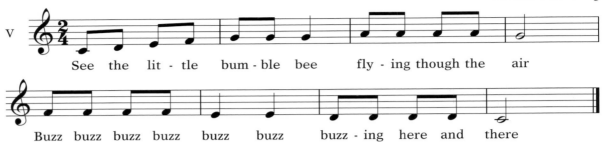

See the lit - tle bum - ble bee fly - ing though the air

Buzz buzz buzz buzz buzz buzz buzz - ing here and there

See the little bumblebee sitting on a rose,
Buzz buzz buzz buzz buzz buzz off it goes!
See the little bumblebee but don't get too close,
Buzz buzz buzz buzz buzz buzz
It might sting your nose!

SINGING GAME

The Bumblebee

- Students sing the song with the teacher.
- At the end of each verse they chant the count-out rhyme (*Bumblebee- bumblebee stung a man upon his knee*) while pointing around the circle.
- Whoever is pointed to last plays an instrumental solo imitating a bee.
- The song starts again.

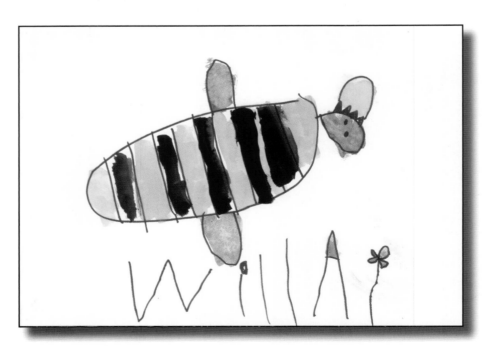

Willa, 4 years old

COLLAGE: BEE

Show pictures of real bees, bumblebees, honeybees and wasps. Provide a good collection of colored paper for collage. Ask the students to make the body of their insect first and add the details later.

Ines, 6 years old

Laura, 6 years old

Thalechan, 5 years old

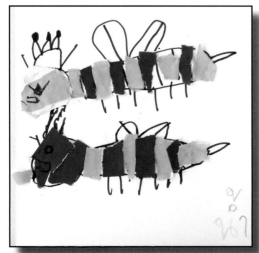

Thirat, 5 years old

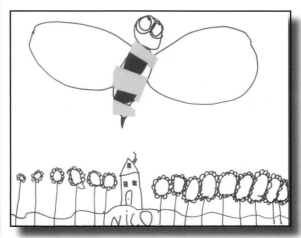

Nico, 5 years old

INK AND OIL PASTELS:
"The Flight of the Bumblebee"

Start with the idea that your paper is a window through which you can see the bumblebee fly by.

Ask the students to use an oil pastel to draw a random pattern starting in any direction. They should be tracing the bee trajectory slowly but with a firm direction.

Fill in the shapes using watercolor, trying not to go over the pastel lines.

Luis, 6 years old

Jaime, 7 years old

Antonio, 6 years old

Malia, 5 years old

Alana, 5 years old

Suggested Children's books

Starosta, Paul. *The Bee*. Toulouse, France: Charlesbridge. 2002.
Cronin, Doreen. Bliss, Harry. *Diary of a Fly*. USA: Harper Collins. 2007.
McGuinness, Elle J. Brown, Heather. *Bee & Me*. Denver: Accord Publishing. 2008.
Aylesworth, Jim. Gammel, Stephen. *Old Black Fly*. New York: Henry Holt and Co. 1992.
Mejuto, Eva. Mora, Sergio. *La casa de la mosca fosca*. Galicia: Kalandraka. 2002.

SNAILS

The snail crawls
Two or three feet
And the day is over.

—Japanese Haiku by Issa

It might be the shape of its shell, the consistency of its body or its slow movement, but snails provoke curiosity in children all over the world. We have rhymes about this curious mollusk from England, Spain, Italy, Germany, France and Japan. Most of them ask the animal to put its "horns" out or else speak of the snail's pace. Snail "horns" are actually tentacles where the eyes and other sensing devices are located.

When disturbed, snails protect their bodies by hiding inside their shell. Unless they are cooked and you are ready to savor them as an appetizer, it is impossible to make a snail come out of its shell. The snail's pace can be a lesson in patience for our children who expect results at the push of a button. That's why we need chants like these:

Snail, snail, Put out your horns, And I'll give you bread And barleycorn. (England)	Caracol, col, col, Saca tus cuernos al sol, Que tu padre y tu madre Ya los sacó. (Spain-Uruguay)
Schneck im Haus, Schneck im Haus, Strecke deine Hörner raus! (Germany)	Chiocciola, chiocciolina, Tira fuori le cornina. Se non le tirerai, Un filo d'erba mangerai. (Italy)

Of the following suggested activities, my kindergarten students' favorite is the traditional tickling game in which a "snail" climbs up the child's arm from the wrist to the inside of the elbow. The inner side of the arm is very sensitive at this age and it is difficult to tell the direction of the movement. Why do children like this game so much? Touching is not only soothing and nurturing, but it is a way of learning: the tactile sense holds an important place in many educational systems, but it should apply to more than objects. The American "no touch" policy in schools has provoked a delicate topic for discussion. The main lesson for students is to learn the difference between "good touch" and "inappropriate touch." This simple, traditional game adds "fun touch" to the spectrum of possibilities, but of course we must respect our students' preferences—some kids might be too ticklish and may prefer just to watch.

SNAIL SNAIL

English Rhyme
arranged by Sofía López-Ibor

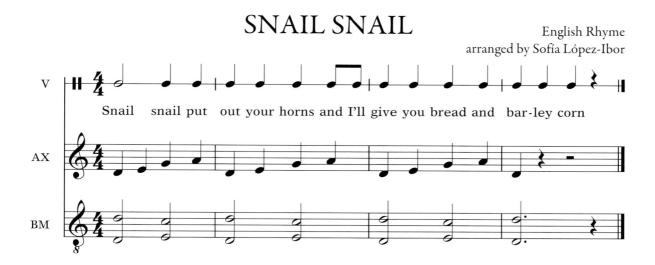

Snail snail put out your horns and I'll give you bread and bar-ley corn

SPEECH

Perform with: crescendo/decrescendo, rising pitch:

Snail snail put out your horns
And I'll give you bread and barleycorn.

Snail snail, put out your horn
We want some rain to grow our corn.

SENSITIVITY GAME

Have the students sit down with a partner. One closes eyes and extends one hand, palm up. Partner makes circles with finger on his or her palm while saying the chant. Then, little by little, partner starts moving up the arm. Recipient feels the "snail" climbing up and when it reaches the middle of the arm, recipient says, "Stop." (Most people say "Stop" too early.)

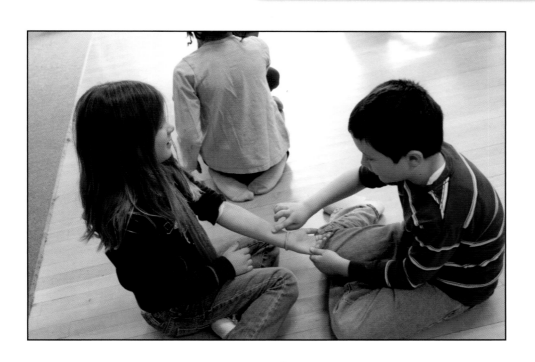

MOVEMENT
The spiral form of the snail is an interesting floor pattern to explore.

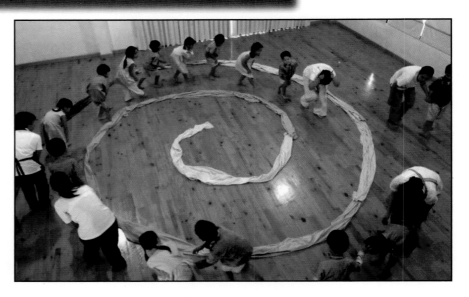

GRAPHIC NOTATION

Make the following graphic score. Imagine 3 snails have crossed a piece of paper and left their trail.

Paint the pattern of each snail's trail in a different color.

Give the students 3 categories of instruments: wood, metal and shakers. Each of the snail lines corresponds to one of the instrumental groups. Music starts when the conductor starts to follow the path of one of the snails.

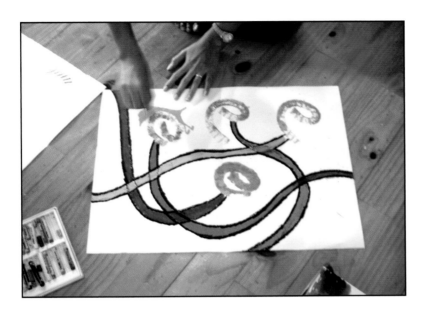

TRADITIONAL GAME
Hopscotch

Draw a large spiral on the floor with chalk. Label the center as "home" and divide the rest of the spiral into spaces. Have the students hop on one foot, landing in each space until reaching the center where both feet land together. If a player completes the circle back they can earn one of the squares and write his or her name on it. The next player needs to get to the center and out again without stepping in another participant's "house." The game continues in this manner until no one is able to reach the center. Whoever has the most "houses" wins.

MARKERS AND WATERCOLOR SNAILS

- To make a snail, ask the students to trace a spiral with a pencil very slowly while saying the rhyme twice.
- Add snail's head and body.
- Color with watercolor paint.

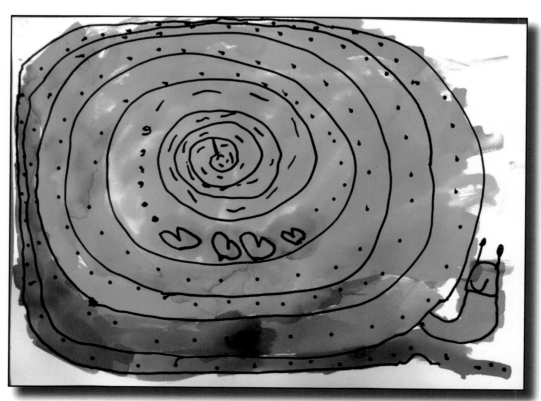

Noppawit, 6 years old

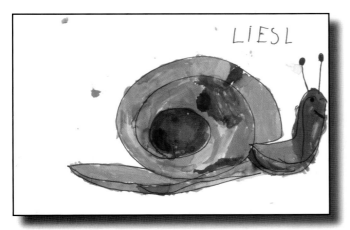

Liesl, 6 years old

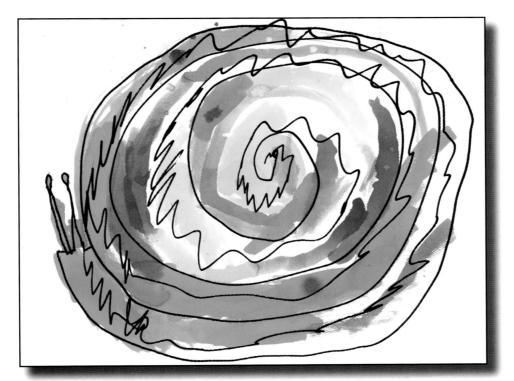

Klijnuth, 6 years old

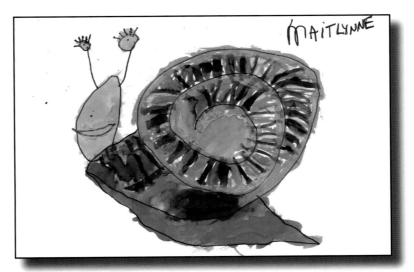

Maitlynne, 6 years old

Thanyapat, 6 years old

Yanakorn, 5 years old

Songpaul, 6 years old

Tipok, 5 years old

PLAY DOUGH RELIEF SNAILS

Ask the students to flatten the play dough on paper. With a pencil, draw a snail and add some texture to the shell.
Make the outline of the snail with a black marker.

Ben, 6 years old

Ben, 6 years old

COLLAGE—INSPIRED BY MATISSE'S SNAIL
Make a collage "alla Matisse" by gluing pieces of paper in a spiral path.

Alanna, 5 years old

Annia, 5 years old

Ava, 5 years old

Jolie, 5 years old

Willa, 5 years old

ENVIRONMENTAL ART
Snails with natural materials

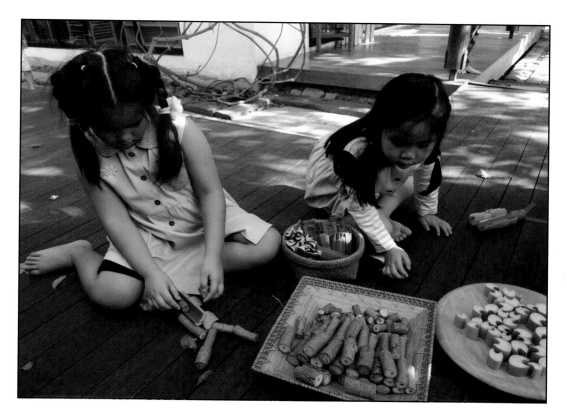

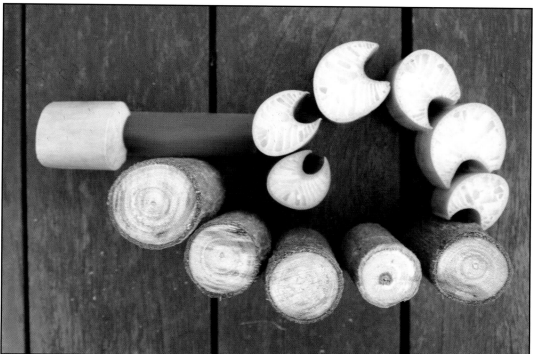

Manucha, 5 years old

Prach, 6 years old

Weesuda, 6 years old

Olivia, 7 years old

Suggested Children's books

Lionni, Leo. *The Biggest House in the World*. New York: Alfred A. Knopf. 1968.

Ungerer, Tomi. *Snail, Where are You?*. United States: Apple Books. 1962.

Allen, Judy. *Are you a Snail?*. London: Kingfisher. 2000.

Kindersley, Dorling. *Fossil*. London: DK. 2004.

MAKE A FACE

The natural expressiveness of children in the preschool years can fade away as they mature. The Orff Schulwerk class is the ideal arena for helping children communicate expressively through speech, gesture, dance and song. Working with songs, poetry and rhyme helps students release emotions and feelings. Practicing a wide spectrum of facial expressions related to the way they are using their voice also helps them explore intonation, volume, pitch and rhythm at the same time.

Symbolic language acquisition is a complex process that can be divided into several progressive aspects: reception, expression and articulation. Receptive language skills include perception and discrimination of words. Expressive language skills allow the child to use gestures, signs and words and help the development of vocabulary. Articulation constitutes the last stage of language development, the skill to express sounds, to fuse them and to produce syllables, words, phrases and sentences that express ideas. All three aspects are closely related, so it is important to attend to all domains of language equally. If gesture is an important component of the development of communication skills, then we need to do some extra work because children today spend too much time connected to electronic media. The aspect of expression is not developed by watching a flat screen that does not respond to the child's gestures, facial expressions and other reactions.

Looking up "inexpressive" in a dictionary of synonyms I found the following: deadpan, dull, empty, fish-eyed, fruitless, hollow, immobile, impassive, inane, inscrutable, lackluster, lusterless, lifeless, mask-like, meaningless, stolid, uncommunicative, vacant, vacuous and vague—adjectives you wouldn't want associated with a child's face.

The art project proposed here is to make a book of interesting expressions to inspire the students in drama games and expressive speech exercises. There are many sources to draw upon for making a mask-like face, from traditional African masks to Matisse and Picasso. There are also inspiring books of facial expressions, particularly "Alla Faccia" by Bruno Munari, which has ideas for creating hundreds of variations on a theme. Even computers have a copious collection of facial icons.

Bruno Munari, image from the book "Alla faccia!", Corraini Edizioni, 2008
© Bruno Munari 1992. Courtesy Corraini Edizioni

DRAMA

Bring a hollow frame for the students to work with. Pass the frame around and let the students explore their favorite facial expressions.

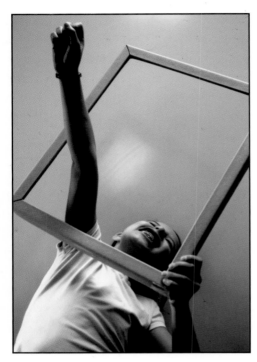

DRAMA

Ask the students to form two teams and sit in a long line facing each other. One team will be performing and the other guessing.

- While the guessing team has their eyes closed, give the performing team one expression, e.g. Happy. Then choose one person on that same team to show the opposite facial expression.
- The opposite team has to guess the one that is different.

GAME

Mirror, Mirror

Mirror, mirror, tell me,
Am I pretty or plain?
Or am I downright ugly,
And ugly to remain?

Circle game. All children skip around one person that is "it" and holds a frame. This person is the "mirror" and the other the "child". At the end of the song the mirror is facing someone and copies the facial expressions of the person, then passes the frame to this person and the game starts again.

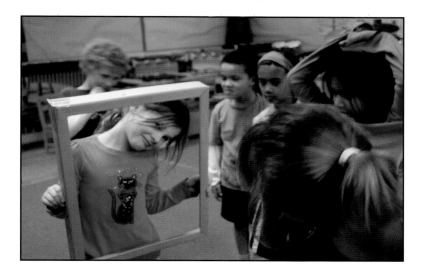

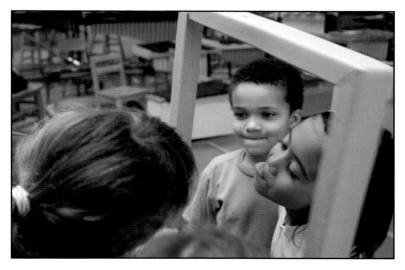

MIRROR MIRROR

Nursery Rhyme
Sofía López-Ibor

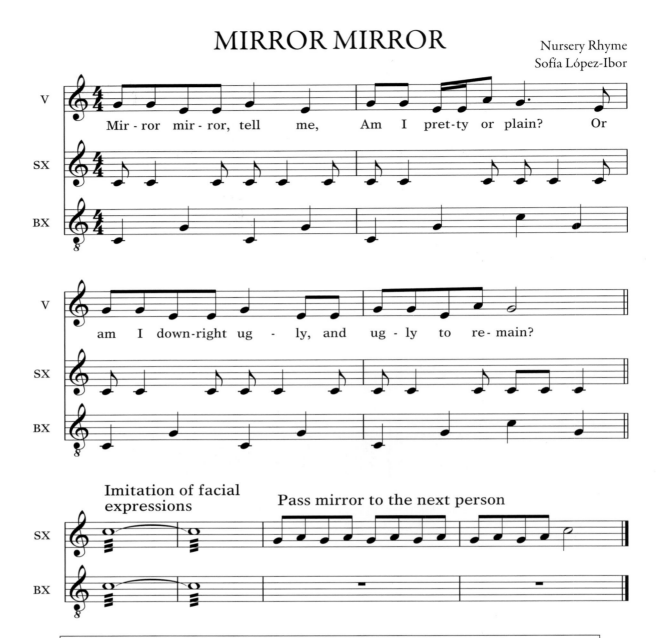

MOVEMENT

Divide the floor space into 4 different fields. Each field is assigned to a part of the body.

- Students move around a particular field showing a particular expression with that body part—"tired," "happy," "curious," etc.
- To an acoustic signal played by the teacher they move to the next field showing the same expression with another body part.

SPEECH

Perform a Nursery Rhyme with different facial and body expressions. Explore contrasting qualities of character, dynamics, tempo and pitch. e.g.

Who comes here?
Here comes Bruce
What do you want?
A glass of juice
Where is the money?
I forgot
Get you gone
This costs a lot!
—(Adaptation of a Mother Goose Nursery Rhyme)

The original rhyme talks about a grenadier asking for beer. A lighter version with young kids is recommended, plus you can make as many variations as you want with the children. (Ann- a cup of bran; Doug- a soft rug, etc.)

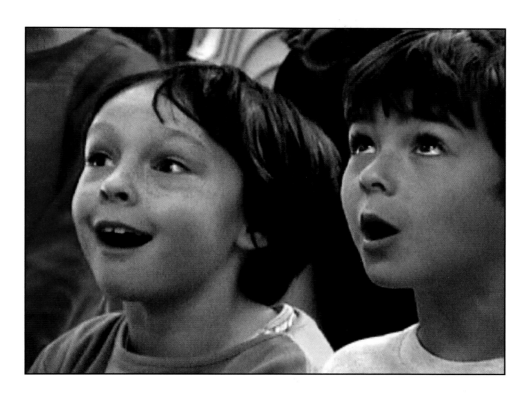

POEMS BY FIRST GRADERS

MAD

Mad is punching
Mad, as mad as a bear
Mad is throwing a tantrum
Mad is exploding someone
Mad is a throwing a tantrum
Mad is wearing a frown

BY ADEN

EMBARRASED IS RED

Embarrassed has a straight mouth
Embarrassed is not doing something
Embarrassed is when someone spots you
Embarrassed is when you're very small
Embarrassed is when you forget your lines in a play
Embarrassed is when you're very small

BY ZOE

OH SO WORRIED

Worried is white
Worried is sad
Worried is worried
Worried is frowning
So worried is worried
Worried is lost, as lost as being lost in the forest
So worried is worried

BY ISABELLA

PROUD

Proud is bright
Proud looks like yellow
Proud is bright
I feel bloomed
I feel happy
I feel proud when my friends play with me
Proud is good

BY SOPHIE

FACES ALLA MUNARI

- Show your students the book "Faccia la Faccia" by Bruno Munari, recommended in this chapter. Notice the symmetric patterns!
- Make faces in black and white with different expressions.

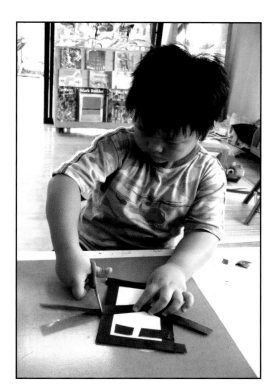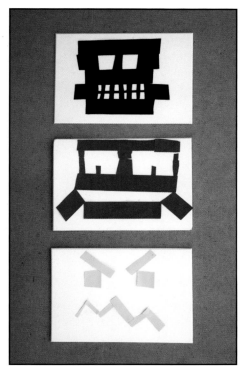

Rawipol, 5 years old

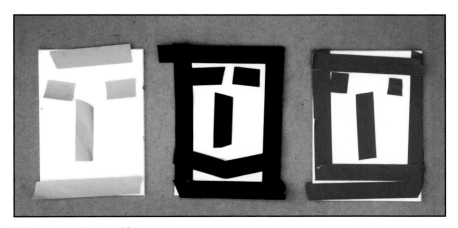

Nakprapan, 5 years old

FACIAL EXPRESSIONS IN YELLOW

- Show your students the face lithographs by Matisse and Picasso.
- Have the students make a simple painted mask showing different emotions and facial expressions.
- Make a book to explore this theme while working with Nursery Rhymes.

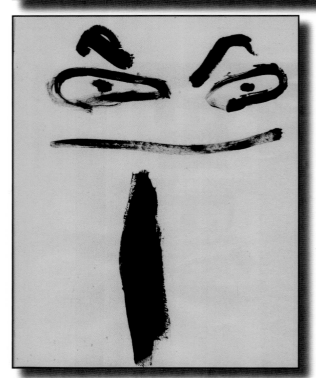

Theo, 5 years old

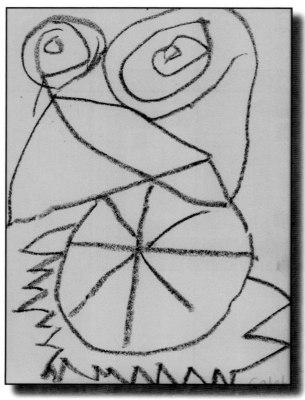

Caleb, 5 years old

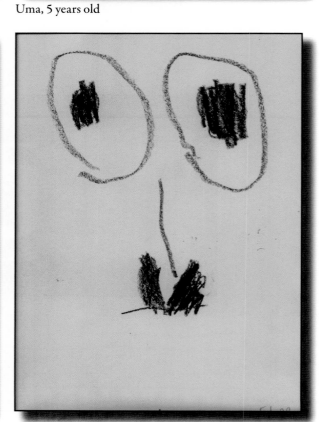

Elyse, 5 years old

Uma, 5 years old

Lily, 5 years old

Sakti, 5 years old

Mirabel, 5 years old

Panita, 5 years old

FACES WITH OBJECTS

Provide an assorted collection of objects for the students to make face sculptures: scissors, pencils, etc.

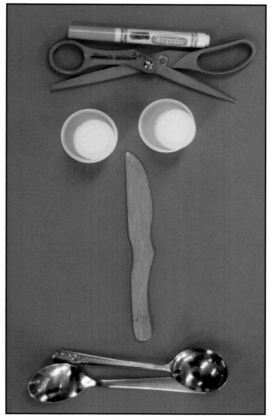

Faces by 6 year olds

FACIAL EXPRESSIONS—ORIGAMI PAPER COLLAGE

Cut the origami paper in pieces to make the face features of each face. Glue them to a basic contrasting colored paper.

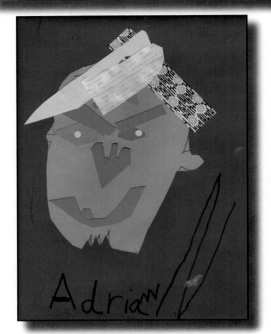

Adrian, 7 years old

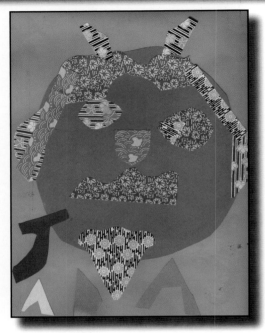

Jada, 7 years old

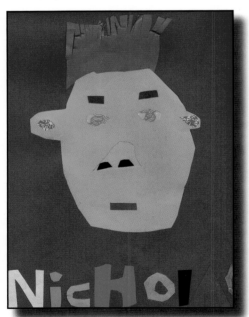

Nicholas, 7 years old

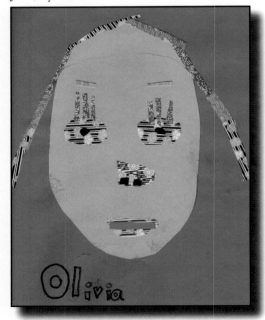

Olivia, 7 years old

Suggested Children's books

Aliki. *Feelings*. New York: Greenwillow Books. 1984.

Munari, Bruno. *Alla Faccia*. Milano: Edizioni Corraini

Thomas, Jan. *Can You Make a Scary Face?* New York: Simon & Schuster. 2009.

Takikawa, Shuntaro. Horiuchi, Seiichi. *Faces*. Japan: Kumon Shuppan. 2009.

Valdivia Dounce, Maria Luisa. *Si No*. Mexico: Oceano. 2008.

Freymann, Saxton and Elffers, Joost. *How are you Peeling? Foods with Moods*. USA: Scholastic. 1999.

BLUE IS THE SEA

Blue is the sea,
Green is the grass,
White are the clouds as they slowly pass.
Black are the cows,
Brown are the trees,
Red are the sails of the ship in the breeze.

Blue is the Sea, a nursery rhyme from England, is a simple poem with beautiful images that I often share with my students. It brings back childhood memories of my favorite landscape—a view of the Malgrats Islands and the Mediterranean from our house in Majorca. I used to play on a porch overlooking the bay and see that same beautiful scene. Day after day I developed my observing skills. I tell my students how the shades of blue changed according to the season, the time of day and the weather. I encourage them to share their own stories because it inspires them to take a moment to breathe, to observe the beauty of the earth whenever the opportunity presents itself.

Landscapes are not only a visual experience. We can use all our senses to have a deeper perception of them, in particular, the sounds we hear in them and the way they are organized. As a vocal warm-up, I often invite the children's choir to improvise a sound landscape, "Imagine you are standing in a forest of tall redwoods, next to a pond. The wind is sliding over the water rustling the trees. A soft rain starts. You hear the sound of the drops falling on the water..." The concentration of the performers intensifies when you have half of the class listening, or if you make a recording of the sounds of the landscape exploration.

This song in La pentatonic was composed as a collaborative project with a second grade class at The San Francisco School. We started reciting the enchanting English rhyme and the children looked for melodic patterns on the xylophones. The musical phrase is short-short-long and the form is A A B.

Two art projects are suggested here, the first one is creating a mixed media mural in the class. I organized the mural making as a collaborative art project. The San Francisco School third graders were sent around the school in small teams with postcard size paper, their own choice of color and technique. They went to the office, library, kitchen and classrooms to find three artists who would paint the postcards. The results were displayed as a big mural in the music room. The second project evokes a fond memory of my childhood: illustrating a song. French class started every week by singing a new song with the lyrics carefully written in perfect cursive on the blackboard by my expert teacher. We sang the song again at the beginning of the lesson on Tuesday and Wednesday. On Thursday we copied the lyrics, practicing our calligraphy. On Friday we made an art piece about the song. With such routine, week after week, I would begin on Monday creating images in my head of the characters, objects and landscapes in the song. It was a powerful way to awaken the imagination and exercise the memory.

Without Reason

1+1 = 2
Feelings are far removed from
Calculations

yellow+blue = hundreds of greens
Reason is far
Removed from art

—BRUNO MUNARI

BLUE IS THE SEA

English Nursery Rhyme
arranged by Sofía López-Ibor

Blue is the sea green is the grass
Black are the cows Brown are the trees

white are the clouds as they slow - ly pass ship in the breeze
Red is the sail of the

MOVEMENT-REACTION GAME

Exploring body figures and developing awareness of the general space are some of the goals of the game.

- Invite the students to form groups of six and assign each participant a color—blue, green, white, black, brown, and red.
- Teacher calls a "color" out of the group and the child runs to a different place in the room.
- When teacher calls "rainbow" other colors join the first color in the new location.
- Encourage students to make a new shape as a group (line, star, statue...).

REACTION GAME

Touch blue,

Your wish will come true!

- Students start in a circle. The teacher says: "touch blue" and they all run to follow the command. As fast as they can, they come back. When everyone is together again teacher says "your wish will come true"
- Children create other rhymes for other colors. (touch red and then go to bed...)

SOUND EXPLORATION

Invite the students to improvise a sound landscape making sound effects with their voices and/or instruments to represent: the sea, the grass and the wind, floating clouds, a forest, and a cow in the pasture.

CHANT-GAME
One color

> One color, two color,
> Three color, four,
> Five color, six color,
> Seven color, more.
> What color is yours?
> (Yellow- Y-E-L-L-O-W)

While participants chant, the leader points around the circle until reaching somebody on the word "more." The person says a color and the leader spells out the word, pointing as he spells. Whoever gets the last letter becomes "it." He/she runs around the circle and the leader tries to catch him before reaching his spot again.

SPEECH AND MOVEMENT
- Ask the students to think of a landscape. Which part of the landscape will have the colors blue, green... etc?
- Reveal the rhyme.
- Have the students form new teams according to color. All people in the "blue" team have to represent the sea with their bodies, "green" the grass, etc.
- Variation—Ask the students to think of an adjective to change the movement quality or dynamics such as "calm sea," "stormy sea"...

CHANTING

Teacher invites students to chant around the circle categories and colors along the circle.

- Blue is the sky, bue is the sea, blue is a flower...
- Whoever does not come up with an idea must change the color.

SINGING

Blue is the Sea

Teacher sings the song a couple of times when the children are still lying down with their eyes closed. Ask the students to sit up slowly and echo each phrase.

- Sing it with a solo-tutti version.
- Sing it in canon.
- Add singing drones.

ORFF ENSEMBLE

Blue is the Sea

The setting of the poem is in La Pentatonic

- Teach the bass xylophone part first and then the alto xylophone with the special ending.
- Make sure the students understand the complementary character of the metallophone and glockenspiel part. The chime adds flavor to the piece.
- Add an improvisation section using the ideas of the poem. Make variations thinking of the time of the day or weather conditions.

RELAXATION

Ask the students to lie on the floor with legs straight, with their hands at their belly. When they are quiet and breathing calmly invite them to think about a landscape: "Imagine you are next to the sea, sitting or lying down on the fresh green grass..."
Focus: stillness and breathing.

LANGUAGE

Blue is the Sea

Focus: Creating variations.
Create a new poem by changing the colors. Imagine the same landscape at night!

POEMS BY THIRD GRADERS

Gray are the hills,
Purple is the sky,
White are the crests of waves riding by.

BY KOJI

Green is the sky,
Blue is the sea,
The girl on the sailboat is red and that's me!

BY VEDA

Red are the trees,
Orange is the sky,
Puffy are the clouds as they roll right by.

BY ANNE

Orange are the hills,
Yellow is the sun,
Brown are the trees to play and have fun.

BY JAMES

LANDSCAPE-CHALK PASTELS

- After singing the song the children can make a painting of the landscape.
- Help the students think about the point of view, the person observing the ocean can be on the shore, on the boat or anywhere else.

Angela, 8 years old

David, 8 years old

Daro, 8 years old

Leah, 8 years old

Timothy, 8 years old

CUBIST LANDSCAPE

Create a cubist landscape based on the song.

- Look at examples from Picasso and Braque.
- Imagine you are looking at the landscape through a diamond or broken glass.
- Divide the drawing space in random geometrical shapes. Try to identify parts of the landscape.
- Color.

Alejandro, 11 years old

Maria, 11 years old

Andrea, 11 years old

MURAL—COLOR PALETTE WITH MIXED MEDIA.

Create a mural combining rectangles (the size of a postcard) by individual students.

CHALK PASTELS

Find all shades of one of the colors. Explore with the following techniques:

- Using the pastel like a pencil
- Drawing with the side of the chalk
- Overlapping different shades and blending them

WATERCOLOR

- Create effects with different brushstrokes by using heavy and light pressure.
- Cover your paper with paint and wash some of the paint off with tissue.
- Wet the paper first and brush with color after.
- Paint with color first and add drops of water on top.

COLLAGE

- Collect pieces of colored paper from magazines.
- Tear small pieces and glue them to the paper.
- Trim the edges.
- Experiment with all sorts of textured paper.

Combine all 3 techniques

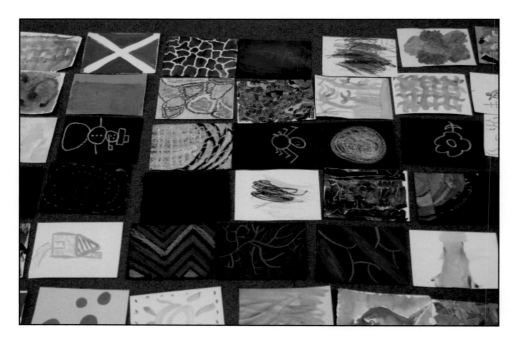

Suggested Children's books

Lee, Suzy. *Wave*. USA: Chronicle Books LLC. 2008.

Locker, Thomas. *Cloud Dance*. San Diego, New York, London: Voyager Books Harcourt Inc., 2000.

Roalf, Peggy. *Looking at Paintings*. Landscapes. New York: Hyperion Books for Children. 1992.

Carle, Eric. *Little Cloud*. New York: Scholastic. 1996.

Louchard, Antonin. *Little Star*. New York: Hyperion Books for Children. 2003.

Jenkin- Pearce, Susie. Fletcher, Claire. *The Seashell Song*. Great Britain: The Bodley Head Children's Books. 1992.

Otoshi, Kathryn. *One*. San Rafael, CA: Ko Kids Books. 2008.

Sidman, Joyce, Zagarenski, Pamela. *Red Sings from the Treetops*. Boston: Houghton Mifflin Books. 2009.

CHICKENS

Every spring the second graders at The San Francisco School hatch chickens in the classroom. Taking care of the eggs by turning them three times a day and witnessing the miracle of life when the chicks hatch is an unforgettable event for the children. That's how this song came to be. The melodic ideas in the song are from Melissa Olague at the age of seven.

The study of birds conducted by a second grade classroom teacher offered another possibility for thematic teaching. Working with other teachers in the school can be very rewarding for the music teacher as it breaks the isolation we often feel and gives coherence to the entire program. We learn how to find connections between subjects and explore those relationships as we plan classes, solve instructional problems and prepare the materials together. We also learn from each other as we observe each other's teaching practices. Creating opportunities for collaboration should be one of the goals of our professional practice. The challenge is that successful collaboration requires sufficient time to plan, to research and to evaluate the results of the work.

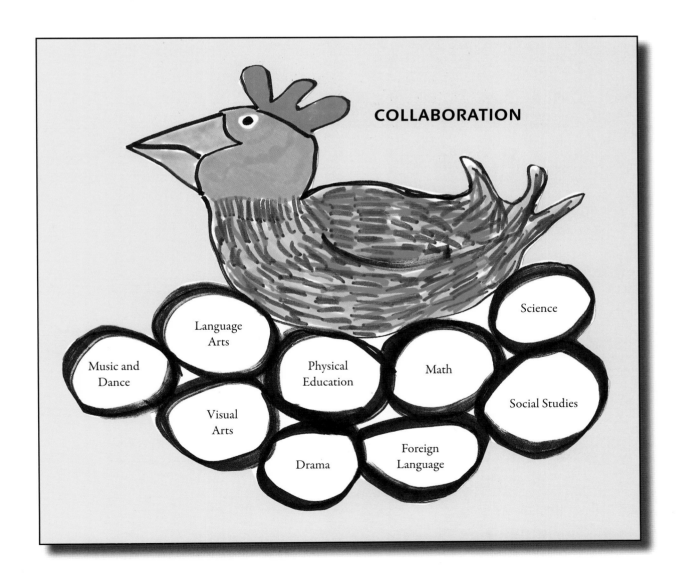

FIVE EGGS AND FIVE EGGS

Nursery Rhyme
arranged by Sofía López-Ibor

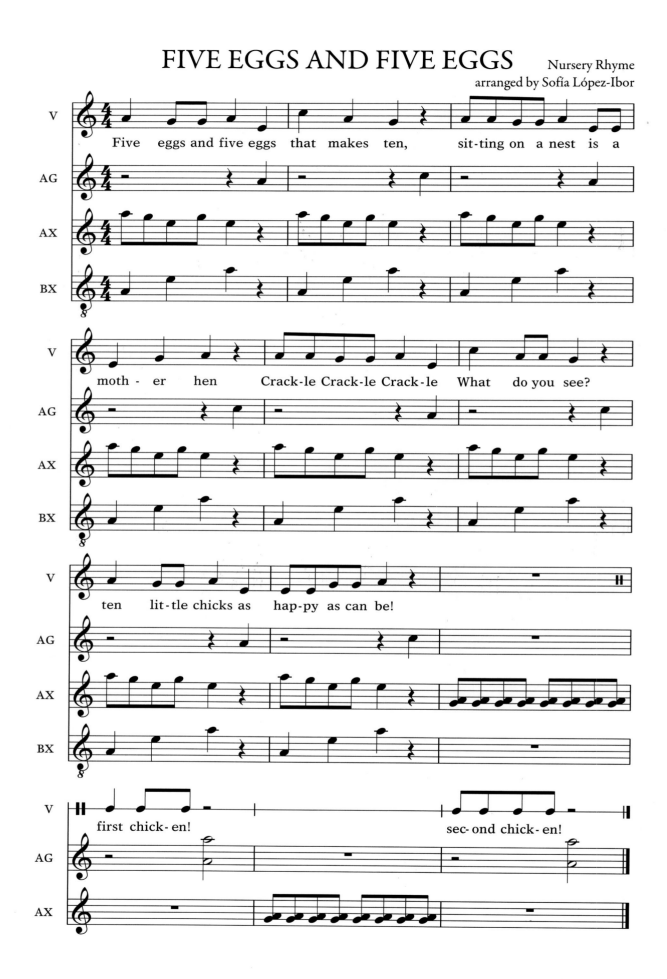

Five eggs and five eggs that makes ten, sit-ting on a nest is a

moth - er hen Crack-le Crack-le Crack-le What do you see?

ten lit-tle chicks as hap-py as can be!

first chick-en!

sec-ond chick-en!

MOVEMENT GAME

Divide the class in two groups ("red chickens" and "blue chickens") with equal number of people. Divide the space with a line in the middle in two fields corresponding to each group. The students in each team are numbered and squat down representing "chickens in the egg". Choose one student to be the "scarf holder", standing in between the 2 lines. This student calls a number and the chickens from each team need to pop out of the "egg" and run to get the scarf. The "chicken" that is able to get the scarf without stepping in the other field runs back to his line. The opponent "chicken" tries to catch him.

"Red" Scarf holder "Blue"

ENSEMBLE

Five Eggs and Five Eggs

This setting of the rhyme *Five Eggs* is in La Pentatonic. BX and AX have parallel quality leaving a space for the "color part" on the glockenspiel. The B section has a text that can be improvised by the children.

SPEECH

Five Eggs and Five Eggs

Have the students think of different types of chickens, or bring photos to show them. Create a speech as a second part to the song (see example in the score)
- First chicken-Second chicken
- Big chicken-Tiny chicken
- Yellow chicken-Black chicken
- Buckeye chicken-Chanticleer

MOVEMENT

- Students draw patterns in a paper egg such as zigzags, dots, spirals, etc.
- Imagine that egg hatches. The chicken will represent the character of the pattern in movement. (moving in a zigzag, for example)

NOTATION

Have the students create a score with four of the egg-chicken folding paper projects. You can create a pattern by opening and closing the egg. Students say or clap the rhythm (egg ♩ ; chicken ⊓)

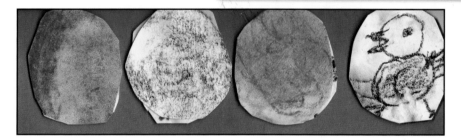

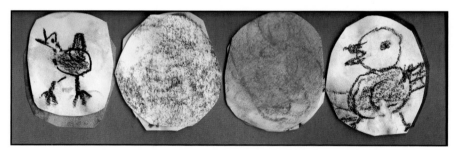

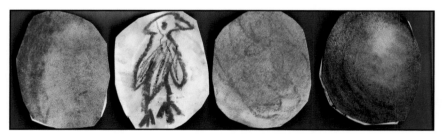

ENSEMBLE

Ta Muzi

The chicken rhyme from China can be performed by substituting the word "muzi" (chicken) by onomatopoeic sounds or small percussion.

Perform with Orff Ensemble accompaniment.

TA MUZI

China

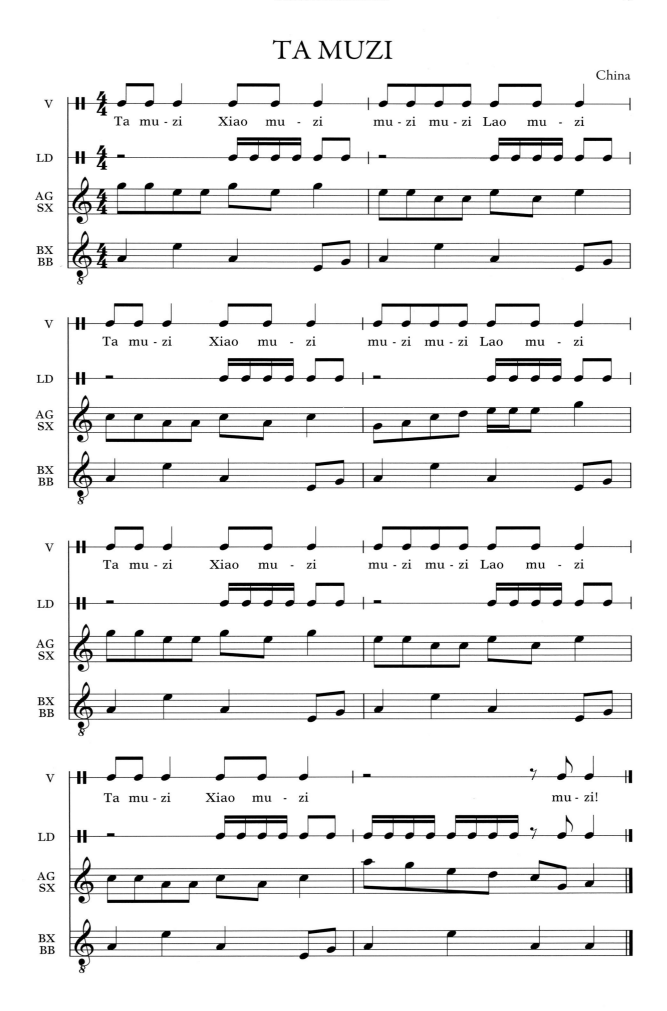

CHARCOAL CHALK AND PASTELS
Illustrate the song *5 Eggs and 5 Eggs*
- Start outlining the composition.
- Make some areas darker (like the outside of the eggs) and spread the drawing surface to create soft transitions.

Layla, 9 years old

Riley, 9 years old

Zara, 9 years old

COLORFUL CHICKENS
Painted with tempera or gouache

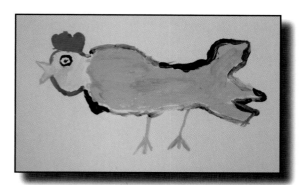

Chananya, 6 years old

Chayanin, 6 years old

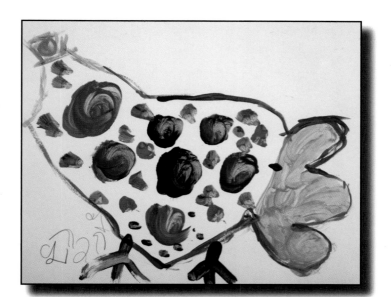

Lapasan, 6 years old

Nattamet, 6 years old

Phakin, 6 years old

Putta, 6 years old

Wongwarit, 6 years old

Tamonrat, 6 years old

MIXED MEDIA EGGS

Based on the book *Hen's Pen*

Decorate individual egg shapes with mixed media.

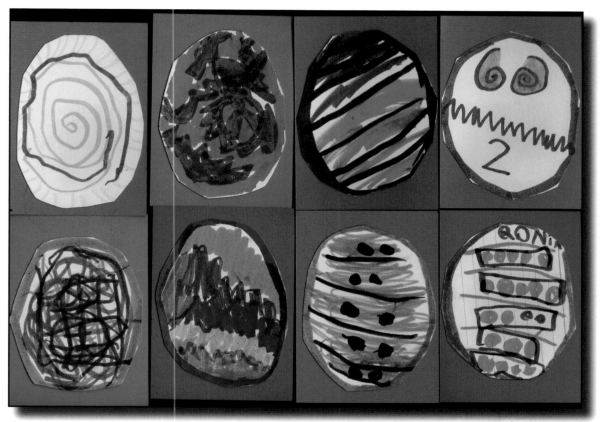

Thalia, Alex, Tommy, Ronin, Willa, Rowan, Ethan, Nora, 4 years old

Suggested Children's books

Fleming, Denise. *Barnyard Banter*. New York: Scholastic. 1994

Harrington, Janice N. Jackson, Shelley. *The Chicken Chasing. Queen of Lamar County*. USA: Farrar, Straus and Giroux. 2007

Roxbee Cox, Phil. *Hen's Pen*. London: Usborne Publishing, Ldt. 2001

Vaccaro Seeger, Laura. *First the Egg*. Connecticut: Roaring Book Press. 2007

Galdone, Paul. *The Little Red Hen*. New York: Clarion Books. 1973.

AIKEN DRUM

The moon has inspired storytellers everywhere. Some see its shadows as animals, such as the Jade Rabbit in East Asia, while others see human forms, such as Tecciztecatl for the Aztecs or Yue-Laou in China. Aiken Drum is a popular Scottish song about a mysterious man living in the moon dressed in a special costume made of food. I learned the song from my colleague Doug Goodkin, who sings it in our preschool assembly, letting the children participate by naming their favorite food.

There was a man lived in the moon, lived in the moon, lived in the moon,
There was a man lived in the moon and his name was Aiken Drum.

And his hat was made of cream cheese, of cream cheese, of cream cheese,
His hat was made of cream cheese and his name was Aiken Drum.

And his coat was made of good roast beef, of good roast beef, of good roast beef,
His coat was made of good roast beef and his name was Aiken Drum.

And he played upon a ladle, a ladle, a ladle,
He played upon a ladle and his name was Aiken Drum.

And his hair was made of spaghetti, spaghetti, spaghetti,
His hair was made of spaghetti and his name was Aiken Drum.

And his eyes were made of meatballs, meatballs, meatballs,
His eyes were made of meatballs and his name was Aiken drum.

There was a man lived in the moon, in the moon, in the moon.
There was a man lived in the moon and his name was Aiken Drum.

This song from the early 18th century is related to a story about a brownie elf in Scotland. Elves are popular characters in the folklore of Northern European countries and are said to live in people's houses and help with small tasks. They are called brownies in Scotland, tomte in Finland, Alve in Norway, huldufólk in Iceland, Domovoi in Russia and Heinzelmännchen in Germany. They work mostly at night because they don't like to be seen by humans. They will accept a reward of little treats, but will abandon the house if they are given large payments or clothes. From Shakespeare to Goethe, the Grimm Brothers to Andersen, Tolkien to J.K Rowling, authors writing for all ages have included these fascinating characters in their stories.

I have introduced Aiken Drum to the students by showing them paintings by Giuseppe Arcimboldo, an Italian painter of the Renaissance who was known for his portraits that made clever use of fruit and other objects. Look at this one upside down.

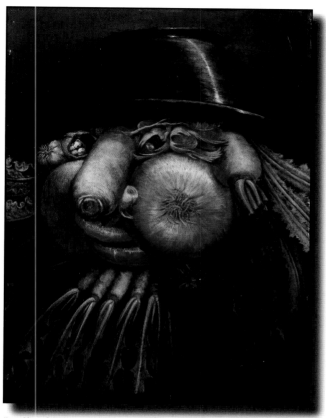

"Still Life"
Erich Lessing / Art Resource, NY

AIKEN DRUM

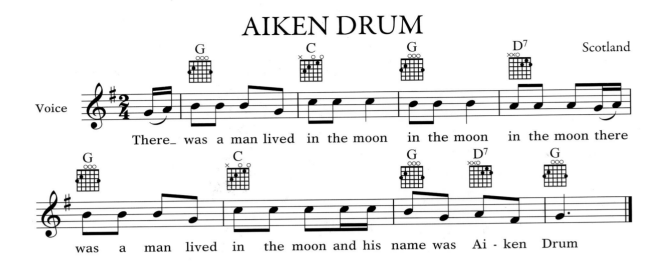

There_ was a man lived in the moon in the moon in the moon there was a man lived in the moon and his name was Ai-ken Drum

SINGING

Aiken Drum

Have the children decide which foods Aiken Drum is made of, "And his hat was made of plum-cake…" to create a new representation of the character.

COMPOSING ART

Aiken Drum

The children choose objects to create a sculpture organizing them on the floor. Then they sing the song with the new lyrics represented in their sculpture.

- Musical instruments ("And his hat was made of a big triangle…") We can also substitute the word of the instrument by the sound.
- Classroom objects ("And his hat was made of colored pencils…")
- Use real fruits

STORYTELLING
Listen to the story of Aiken Drum and perform it as a play. Have the students think about their favorite character and choose a simple prop or hat to identify it. Invite them to improvise movements and memorize the chanting parts.

Comment: Elemental plays are based on the idea of repetition and include many opportunities to include improvised music, song and dance.

PLAY—AIKEN DRUM

Narrator:	Once upon a time there was a small town in Scotland called Blednock where people were grouchy all the time because they had too much work to do.
	Farming, Milking, Baking, Knitting, Sharpening scissors, Making keys, We can never be at ease!
Farmer:	Can you help me cut my grain before the winter comes?
Baker:	Not before you help me make some cracker crumbs!
Key Maker:	Can you help me make some keys?
Milkman:	I am carrying my fresh milk to make delicious cheese!
Baker:	I wish I had help in my bakery.
Farmer:	I wish I had help on the farm.
Key Maker and Milkman:	We all need help, we cannot help our customers.
Baker and Farmer:	We are tired and unhappy!
Narrator:	Life was hard for those poor workers—they never had time to rest or have fun. One day, as they were going about their busy life, they heard an intriguing voice singing in the distance.
Aiken Drum:	Have you any work for Aiken-Drum, Aiken-Drum, for Aiken Drum? Have you any work for Aiken-Drum? Any work for Aiken-Drum?"
Narrator:	They looked to the horizon but they did not see anyone. They looked to the left but they did not see anyone. They looked to the right but they did not see anyone.
Farmer:	I hear a voice. Who sings so well?
Key Maker:	The voice sounds clear like the town bell!
Milkman:	I hear it too! But I can't see anything.
Baker:	The singing is beautiful, I agree.
Narrator:	They kept looking but still couldn't see anyone. Then they heard the sound of a drum.
Farmer:	I hear a drum go thump, thump, thump.
Key Maker:	The sound is making me jump, jump, jump.
Milkman:	I hear it too but I still can't see anything.
Baker:	Maybe we should climb the apple tree!
Narrator:	Soon all the people in the town came to the square and here's what they heard.
Aiken Drum:	Have you any work for Aiken-Drum, Aiken-Drum, for Aiken Drum? Have you any work for Aiken-Drum? Any work for Aiken-Drum?
Villagers 1:	We hear a voice, Who sings so well? The voice is clear like the town bell!.
Villagers 2:	We hear it too! But we can't see anything. The singing is beautiful, we agree.

Villagers 1: We hear a drum go thump, thump, thump, the sound is making us jump, jump, jump.

Villagers 2: We hear it too but we can't see. Maybe we should climb the apple tree!

Girl: Look, look! I see a funny little man coming down the street.

All: What? We still can't see anyone!

Boy: I see him too but he is only as big as me. Aiken drum: Have you any work for Aiken-Drum, Aiken-Drum, for Aiken Drum? Have you any work for Aiken-Drum? Any work for Aiken-Drum?

Girl: The man is small.

Boy: I agree—he is not tall.

Girl: His eyes are big.

Boy: Like a blue fig!

Narrator: Why did only children see the mysterious man? The grown-ups couldn't see him because they couldn't trust the children. But then a grandmother, the oldest woman in the town came walking down the street. She had heard the singing too and she knew exactly what the children were talking about.

Old Woman: This little person is an elf. In Scotland we call them brownies. His name is Aiken Drum.

All: Aiken Drum! An elf?

Old Woman: My grandmother used to tell me about brownie elves when I was a child like you. Brownies are little people who love to work; if you are good to this one he will help to get all your work done.

Narrator: Every new moon night the brownie elf, Aiken Drum, came to the town. Grandmother would leave bread and milk for him at the window and every morning the treats were gone. Everyone noticed that the work was getting done.

Farmer: Cutting the grain is fun today, fun today, fun today, Cutting the grain is fun today while I think of Aiken Drum.

Milkman: Milking the cows is fun today, fun today, fun today, Milking the cows is fun today while I think of Aiken Drum.

Key maker: Hammering here and hammering there, hammering there, hammering there, Hammering here and hammering there, while I think of Aiken Drum.

Baker: Melting the butter and sugar sweet, sugar sweet, sugar sweet, Melting the butter and sugar sweet, while I think of Aiken Drum.

Narrator: Aiken Drum became a very famous brownie. He worked and helped everyone a little bit, but the real truth is that everyone got more done simply because they were happier and sang while they worked.

Farmer: Cutting the grain is fun today, fun today, fun today, Cutting the grain is fun today while I think of Aiken Drum.

Milkman: Milking the cows is fun today, fun today, fun today, Milking the cows is fun today while I think of Aiken Drum.

Key Maker: Hammering here and hammering there, hammering there, hammering there, Hammering here and hammering there, while I think of Aiken Drum.

Baker: Melting the butter and sugar sweet, sugar sweet, sugar sweet, Melting the butter and sugar sweet, while I think of Aiken Drum.

Narrator:	Finally the people were so thankful to Aiken Drum that they decided to do something good for him. They made a green hat and a vest for him and left their favorite food on the town square for him to take.
Grandmother:	No, no, no! You shouldn't do that. Brownie elves just work for the love of working. If you try to reward a brownie with too many treats he will leave and never come back.
All:	Cookies, peanut butter, pasta, ice cream, Cookies, peanut butter, pasta, ice cream.
Narrator:	Aiken Drum found the hat and the vest. And he knew they were for him.
Aiken Drum:	Green hat and green vest, the perfect color for me! But now I must leave and find another place where I am needed. I can't stay here any longer.
Narrator:	He also saw all the food under the apple tree and decided to take all of it. He left the little town carrying all the food in his arms, his head, his back…. He was even balancing something on the tip of his nose. The adults who couldn't see Aiken Drum think about him every time they need to get a lot of work done.
Farmer:	Cutting the grain is fun today, fun today, fun today, Cutting the grain is fun today while I think of Aiken Drum.
Milkman:	Milking the cows is fun today, fun today, fun today, Milking the cows is fun today while I think of Aiken Drum.
Key Maker:	Hammering here, hammering there, hammering here, hammering there, Hammering here, hammering there, while I think of Aiken Drum.
Baker:	Melting the butter and sugar sweet, sugar sweet, sugar sweet, Melting the butter and sugar sweet, while I think of Aiken Drum.
Narrator:	Now that they were happy, it always seemed like the work got done faster and easier than on days when they were grumpy and sad. But where did Aiken Drum go? Grandmother knows that Aiken Drum left them and lives on the moon. If you look closely on a full moon night you will see a mysterious shadow….

GAME

The man in the moon

Focus: So-mi melody, pentatonic improvisation, 6/8 meter

The man in the moon,
Looked out of the moon
Looked out of the moon and said,
"It's time for all the children on earth
To think about getting to bed!"

Ask the children to form a circle with one person in the center who is "it." They all skip around while saying the first part of the rhyme. The child in the center says the second part of the rhyme and then plays a glockenspiel solo, while the others start melting onto the floor and pretend they're sleeping.

THE MAN IN THE MOON

Mother Goose Nursery Rhyme
Setting by Sofía López-Ibor

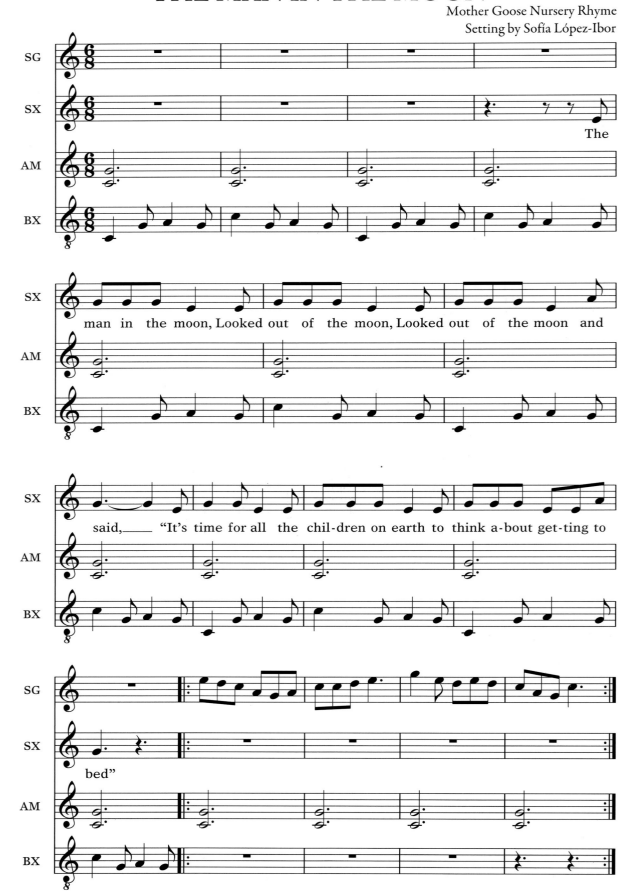

COLLAGE
Make a "collage" portrait of Aiken Drum with food products (clip photos from food magazines).

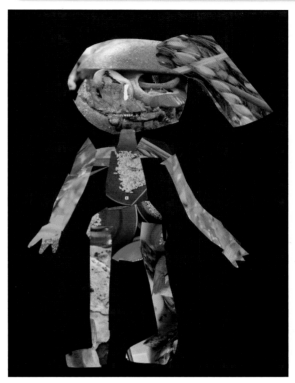

Arden, 7 years old

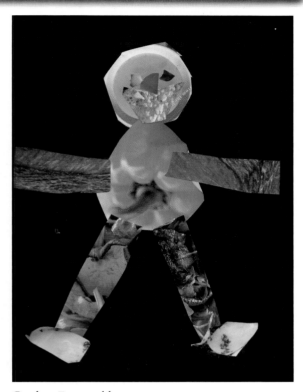

Gordon, 7 years old

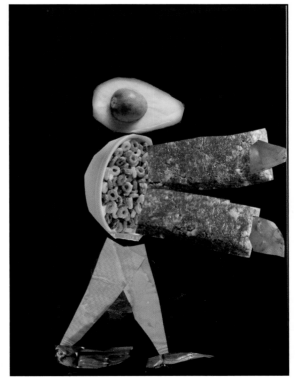

Jack, 7 years old

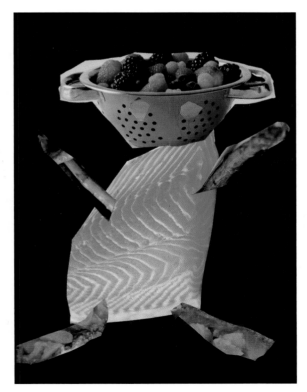

Liam, 7 years old

PEZZETTINO

A few years ago a small group of quilters from Gees Bend, Alabama, came to visit The San Francisco School. This collective of women artists is famous for making the stunning quilts that can now be seen in museums all around the country. The quilters sang with our children, participated in the art class and told us their amazing life stories. One of the women used all the clothes her husband wore to make a quilt after he died so that whenever she missed him she could wrap herself in it. I love the idea that a piece of art can be more than a pretty design, that it can carry so much information about someone, square after square of remembrance and stories.

Some of the beautiful quilts resemble a painting by Paul Klee entitled Static-Dynamic Gradation, which also reminds me of one of my favorite characters in children's literature, "Pezzettino."

© [2011] Artists Rights Society (ARS), New York

Leo Lionni is the author of Pezzettino ("little piece," in Italian)*, a small orange square who is convinced he must be a part of someone else. The story is the journey of self-discovery undertaken by Pezzettino as he encounters others with his questions.

In this lesson, I propose playing with small squares of fabric (stretchable book covers which come in various colors work well; they free the student's imagination). Using them as a piece of a puzzle, we create and re-create the characters in the Pezzettino story while listening to music that helps identify those characters. Students can later compose their own pieces and present the story as movement and drama.

* Lionni, Leo. *Pezzettino.* Alfred A. Knopf. New York; 1975

PUPPETS

- Each student gets a book cover that can be used to make figures (hand is inserted to create a snake, snail, frog, bird, butterfly, etc.). They share their discoveries in the circle.
- Groups of four or five students create other figures together: a flower that opens and closes, animals, etc.
- Create a little scene with figures moving to recorded music.

MOVEMENT

- Explore the movement qualities of each character in the story Pezzettino.
- Students form groups to plan a performance of the story.

COMPOSITION

Students create shapes on the floor by combining the book covers. They collaborate to form the main characters of the story with the book covers.

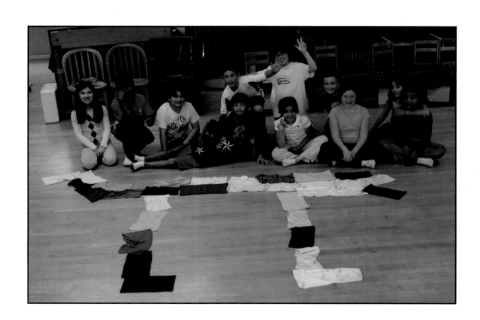

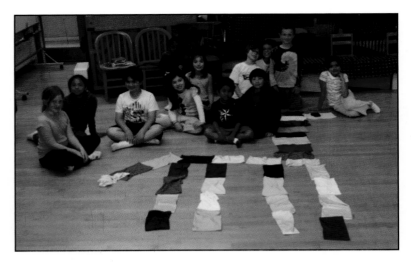

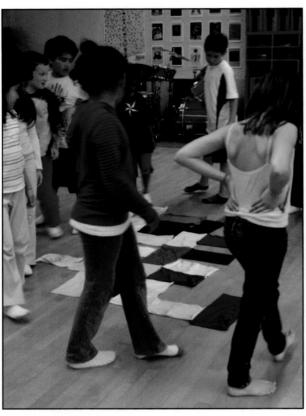

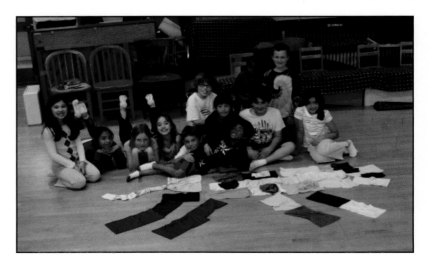

MUSIC LISTENING

- The teacher chooses a musical piece to match each character in the story of *Pezzettino*.
- The teacher reads the book and plays the appropriate piece when the character appears.
- Discuss the qualities that identify each character according to the music chosen.

COMPOSITION

- Have the students choose one of the characters in the book to portray in a piece with Orff instruments.
- Students should discuss the musical parameters that would make their piece relate to a particular character.
- Read the story and perform the pieces.

COLLAGE

- Create your favorite character from the story *Pezzettinno*
- Using fabric squares
- Colored paper squares
- Painting your own squares
- Projecting squares on a screen

Eloy, 5 years old

Alba, 14 years old

Sofia, 4 years old

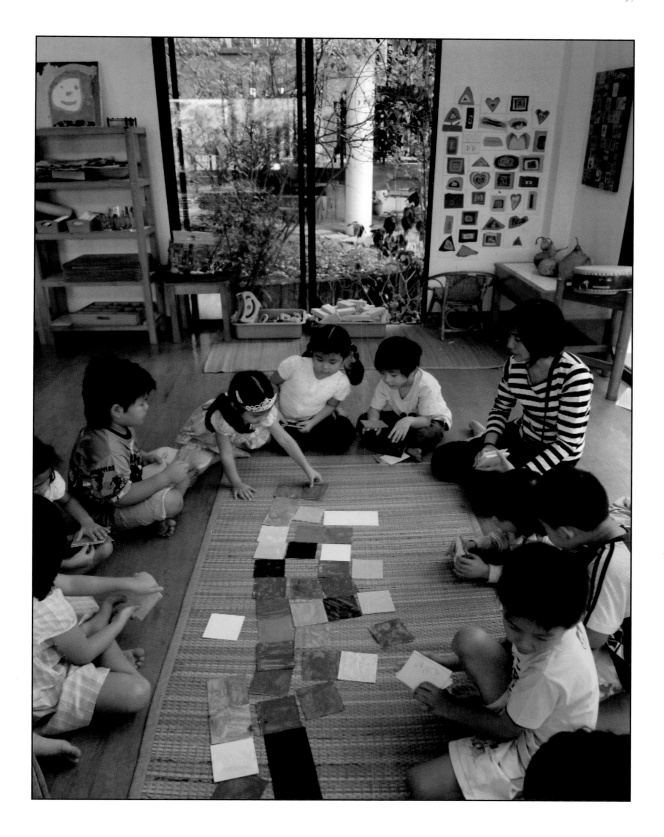

Punnantornnnn, 4 years old

Suggested Children's books

McKissack, Patricia. Cabrera, Kozbi A. *Stitchin' and Pullin'*. New York: Little Random House
 Children's Books. 2008
McKee, David. *Elmer*. London: Andersen Press. 1989.
Lionni, Leo. *Pezzetino*. New York: Alfred A.Knopf. 1975

DANCING DOLLS

*"En educación musical no hay nada mas difícil
que formar un buen círculo con los alumnos."*

(There is nothing more difficult in music
education than to make a good circle.)

—ELISA ROCHE

That was one of the first lessons I learned from my mentor, Elisa Maria Roche and every time I teach a circle dance I think about it when I see kids pulling, pushing, or getting too far in or out. Holding hands is especially challenging because losing balance is terribly contagious! Stepping in and out presents the added difficulty of not taking too big or too small a step and stepping to the right and left can be very confusing when the students try to mirror the teacher.

When you want: you get:

When students are dancing they are so inspired by their steps and jumps that they forget to pay attention to the group shape. There are many ways to help your students dance in a beautiful circle. Games of passing objects, clapping games and other circle activities help train the young child to observe and maintain the circle.

The activity I propose here is to create dolls to use for practicing the basic dance moves. By using the dolls as a way to personalize the dance moves, the children can see the importance of coordinating with, and responding to each other. When students plan a dance for the dolls they naturally verbalize what they want to do: "first we move to the left and then up..." Here, we are giving the students an opportunity to learn what is important in a different way. Then, when writing their choreography or teaching it to other children, they can apply what they have learned in a new context.

ALLA IRISH

melody: Althea Fyfe, 12 years old
arranged by Sofía López-Ibor

MOVEMENT

In small circles students choreograph dances for the dolls using the basic forms of folk dance:

- In and out of the circle
- Walking to the left
- Walking to the right
- Side steps to the right and left
- Facing dance direction
- Do-si-do
- Bowing

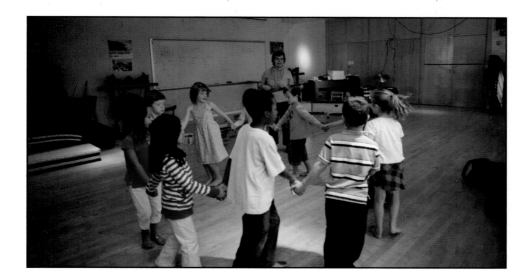

Filming the students' dance with the dolls gives them a bird's-eye view of the basic dance forms.

MOVEMENT

Ask the students to reproduce the dance steps while teaching them to another group. Students make a list of the basic forms they used in each group.

CONCENTRATION GAME

Leave all the dolls on the floor. Give the students sufficient time to observe the paper dancers well.

Have the students close their eyes while you hide or change the order of the dancers. They have to guess what changes were made.

MAKING DOLLS

Use a spoon, brush or other utensil as the basic structure for the doll.
For clothing and hats use ripped paper, feathers, yarn, thread and beads.

Maya, 6 years old

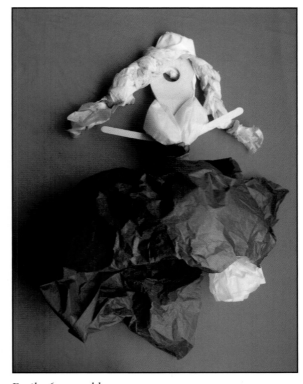

Emily, 6 years old

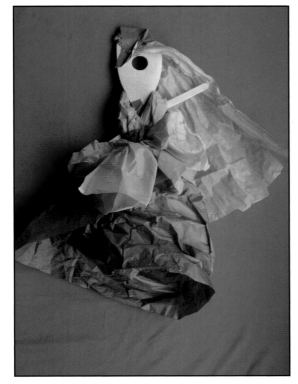

Alma, 6 years old

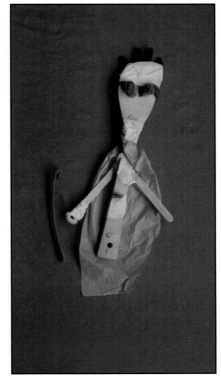

Kai, 6 years old

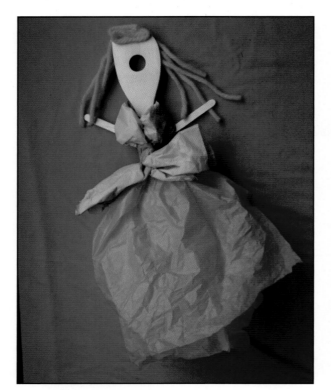

Annika, 6 years old

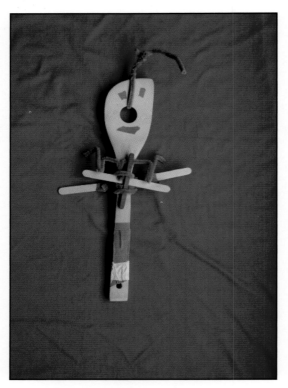

Daniel, 6 years old

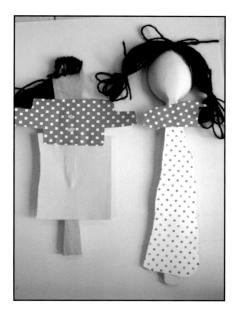

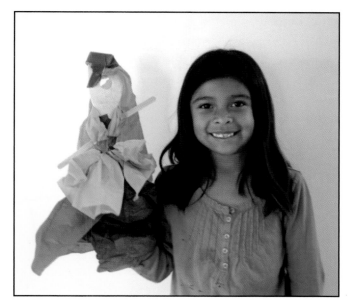

Carmen, 5 years old and Sofia, 4 years old

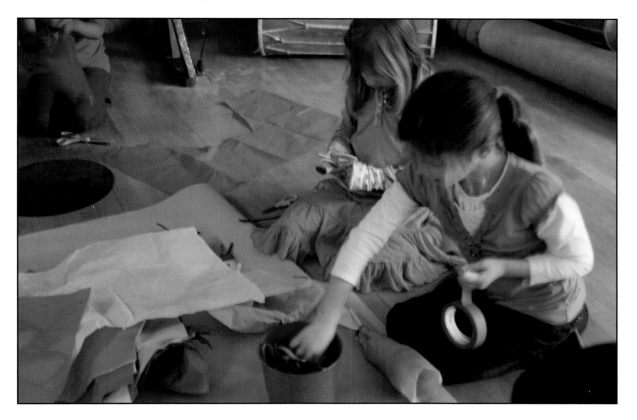

NEWSPAPER

Cardboard tubes, paper bags, rubber bands, ping-pong balls, sponges, chopsticks and scarves fill the cabinets of my teaching room. Every music and dance teacher can find simple objects to inspire activities that will cultivate their children's creativity and their own. The use of objects in the context of Orff Schulwerk was the theme of my final thesis at The Orff Institute in Salzburg. I wanted to write about stimulus and motivation as it applies to music and dance pedagogy because I love the idea of exploring with the simplest objects of daily life.

Once, while waiting for a delayed flight at Heathrow airport, I noticed a boy also waiting who had nothing to play with but a long shoelace. I was fascinated, and inspired by the many ways he found to interact with the only "toy" he had at hand. I watched and listed at least 30 different activities he invented, from swinging the lace in the air as a propeller, to tying, to measuring, to imitating movement, to tossing and catching the string. All of that was independent play, until his mother taught him a version of "cat's cradle."

Children these days have much less time for spontaneous play: computers, TV and an electronic world are depriving them of opportunities just to "mess around" with something simple. But the simplest objects can be more interesting to explore than the most sophisticated. Children love open-ended toys that they can use in a thousand ways; they not only find pleasure in the exploration but they start making connections with the world around them. This is how they learn problem solving and critical thinking. As Alfred North Whitehead says, "The mind is never passive; it is a perpetual activity, delicate, receptive, responsive to stimulus. You cannot postpone its life until you have sharpened it." *

Playing with everyday objects in music and dance class became the subject of my research and it became clear to me that what happens spontaneously with a child, like the boy in the airport, doesn't happen with a large group of students. What I try to bring to my lessons are the basic principles of exploration that lead us to precise learning goals. Some of those principles regarding objects are:

- The objects are intriguing; they cause children to wonder what to do with them. They have infinite possibilities of exploration. (How can we use a newspaper?)
- They can instantly be something else. (Can a newspaper turn into an umbrella?)
- While manipulating them, children explore concepts of size, weight, shape, space, and sound. (Can you make a loud sound with a newspaper?)
- They can be organized, or sorted. (Let's make a big square out of the papers—or a long pathway.)
- You can develop a relationship with the object. (Can you carry it over your head? Can you put it on the floor and skip around it?)

"Can I take this paper home?" a student asked me after a newspaper class. "Of course. What are you going to do with it?" I answered, looking at the crumpled paper in her hand. "I don't know yet!"

* Alfred North Whitehead. *The Aims of Education.* (p. 18). Mentor Books, New York. 1929.

SOUND EXPLORATION

Every student in the circle shares a sound they create from a piece of newspaper by rubbing, patting, wrinkling or tearing.

They play a musical piece together called: Stormy Weather

PANTOMIME

Have the students sit in a circle holding the newspaper in front of their faces, showing only the eyes. The teacher leads the activity by playing a short sound on a triangle and a woodblock.

At the sound of the triangle, one person puts the newspaper down and shows a facial expression.

MOVEMENT

Give the students a sheet of paper and lead a movement exploration
Tossing and catching
Balancing on different parts of the body.

LANGUAGE

Invent a speech piece or a movement poem using random words selected from a newspaper.

Lyla, 9 years old

Lucia, 9 years old

Shalamar, 9 years old

MOVEMENT

Each student has a newspaper. Ask them to stand in a line. The goal of the game is to get across the room without touching the floor by stepping on the newspapers. The first person lays the paper on the floor and steps on it. The second passes the paper forward. The first person steps on the second paper, etc. until they are all on the other side.

MOVEMENT GAME

The only important rule for this game is not to tear the paper!

Each student has a page of newspaper placed anywhere on the floor. Standing on the paper with feet together, rooted like a tree, the child imagines this to be his or her "house." When the teacher starts playing music, the children leave the paper and run anywhere in the room. When the music stops they have to get back to their "house" as fast as they can. They can play the game with other motions: skipping, hopping, walking, sliding...

Variation: Every time they come back to the "house" they step in. Then they step out and fold the paper in half. They step back in and the game starts again. As the paper gets smaller, their balance is harder to maintain!

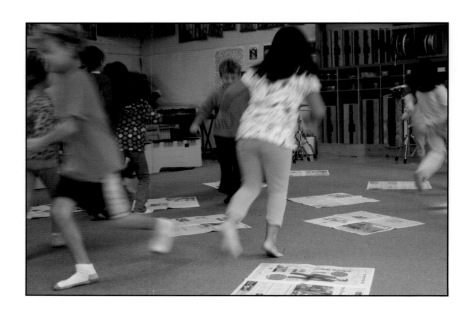

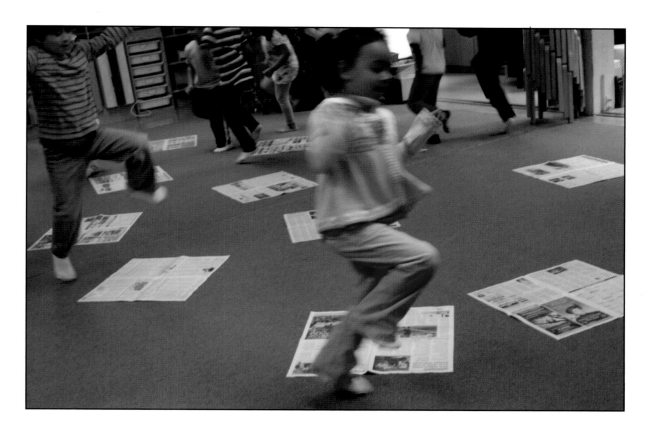

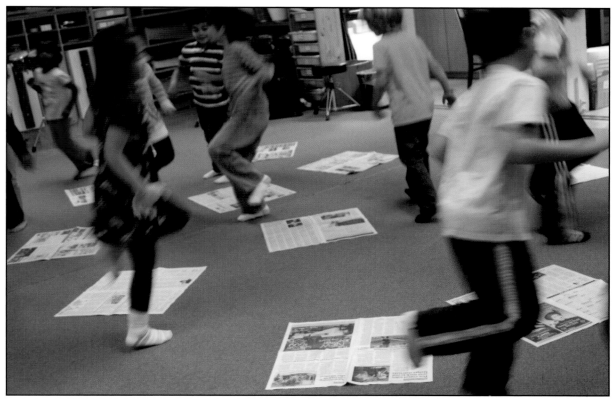

DRAMA

Students make their newspaper puppets dance in the shadow theater (see art project) and try to express the feeling of the music. Two puppets can dance at the same time but the puppeteers need to communicate non-verbally

SINGING

Students face each other holding either end of a single page of newsprint. The paper should always be taut but without tearing.

One person walks backwards slowly, pulling the paper causing the other person to follow. At the moment this person stops or releases the tension, the other one starts walking backwards to maintain the tension.

As above but singing a long note on the syllable "Ooh." The person pulling sings; the other listens.

GAME

Have the students make a ball with the newspaper and play the passing game Dikole from Cameroon. The song translates, *leave me some of the food.*

DIKOLE

Cameroon
Dii

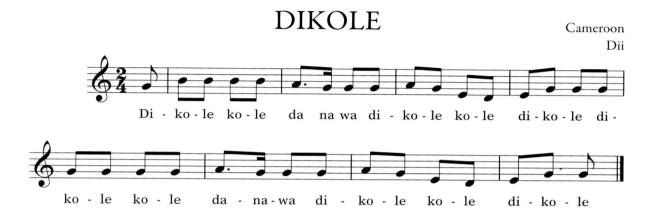

Di - ko - le ko - le da na wa di - ko - le ko - le di - ko - le di -

ko - le ko - le da - na - wa di - ko - le ko - le di - ko - le

NEWSPAPER ANIMALS

Make a small animal with nothing other than a piece of newspaper.
Project its shadow on a screen.

Shalamar, 9 years old

Nathan, 9 years old

Jazara, 9 years old

Alfie, 9 years old

Layla, 9 years old

PICTOGRAMS

Egyptian

Mayan

Here are two different ways of representing my first name. The idea of conveying meaning through a symbol that resembles a physical object is as old as some of the earliest forms of writing and is still used in some cultures. Nowadays, airports and roads are using a universal pictographic language to communicate non-verbally.

Drawing simple pictograms representing the text of a rhyme, song or poem can be a helpful tool to capture the young eye's attention, and particularly non-readers. This is especially helpful when you are working with texts in a foreign language, where you need the students to memorize the sound and remember the meaning at the same time.

Here are some basic ideas for creating a pictogram:

- The text needs to be simple. Numbers, letters and repeated words work best.
- The pictogram is done on a large scale, so that all students are looking at the images at the same time.
- Reading direction does not have to be the conventional left to right or top to bottom.
- The drawings and symbols can represent gestures, body actions, melodies, rhythms and dynamics.

PICTOGRAM

Uno, dos, tres, cuatro
Margarita tiene un gato.
 Spain

This pictogram helps the children remember the words of the song, and also allows us to try many variations of the rhyme by simply pointing to the figures while the children chant.

Variations on the text:
Una, dos, tres, cuatro
Margarita tiene un gato
Tiene un gato Margarita
Una, dos, tres, cuatro.

Margarita tiene un gato
Una, dos, tres, cuatro
Tiene un gato Margarita
Una, dos, tres, cuatro.

Una, dos, Margarita
Tiene un gato, tres, cuatro,
etc.

PICTOGRAM

Tony has a hat!
And, what do you think of that?
Take it off, pass it on and
Clap clap clap.
Kyle has a hat...

A simple name game for young pre-schoolers! You can play it wearing a real hat that pass from child to child but watch out for a head lice epidemic! The game can be used as an introduction to a movement class in which the children move like characters wearing a particular hat. For this activity I use the book "Hats" by Andy Warhol. Children can draw their own hat collection!

TREES

Every year we have a school-wide theme at The San Francisco School to promote collaboration among the teachers, and in 2008 our theme was trees. Trees grow by gathering nutrients with their roots and extending their branches into the air, an image we can compare with growing and learning. They are also metaphors for life and history. Trees are for children to climb and play in as well as a subject of study in the sciences, language arts, math, visual arts, music and drama.

Over the years, I've found that organizing music and dance curriculum thematically is very rewarding—it engages students in a way that helps them see relationships among concepts. With almost any topic you can create a thematic unit to match the full spectrum of activities you do in the class. This constitutes not only a well-organized plan but is also a basic research method.

Here are some examples for collecting material on the theme of trees:

- Gather stories, songs and nursery rhymes about trees.
- Look for dances that suggest trees: dancing around them, imitating their shape or movement.
- Make a list of types of trees. Use it to create a speech piece: "Tan oak, live oak, Ponderosa Pine."
- Find traditional games that have trees as a theme.
- Look for sayings and proverbs about trees to create a speech piece.
- Invent a tongue twister about trees.
- Play folk and classical music about trees.
- Present a class on music notation based on the rhythm of language (use names of trees).

From the many songs about trees we have in the school repertoire, I chose the famous Japanese song "Sakura" about cherry blossoms in spring.

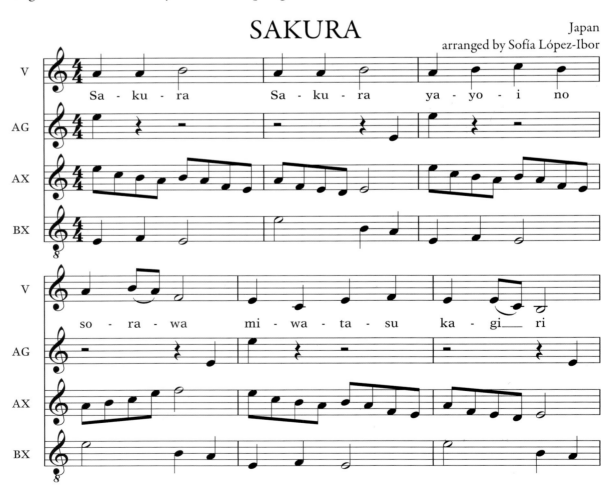

SAKURA

Japan
arranged by Sofía López-Ibor

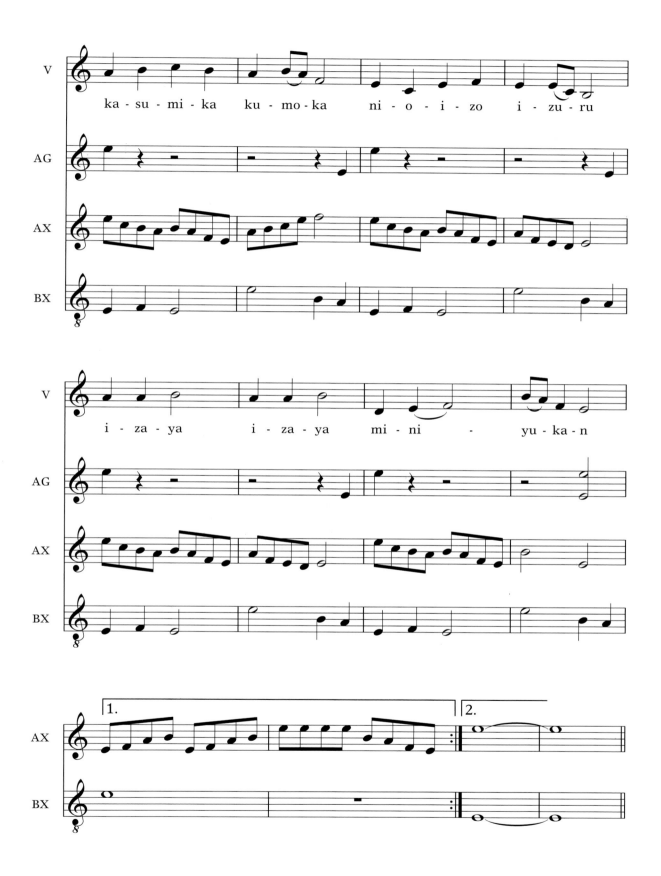

ka - su - mi - ka ku - mo - ka ni - o - i - zo i - zu - ru

i - za - ya i - za - ya mi - ni - yu - ka - n

SINGING
Sakura

Students learn the song and play the musical accompaniment on the Orff instruments. An improvised section in pentatonic is added after the song.

さくら　さくら
やよい　の　そら　は
みわたす　かぎり
かすみ　か　くも　か
におい　ぞ　いづる
いざや　いざや
みに　ゆかん

sakura sakura
yayoi no sora wa
mi-watasu kagiri
kasumi ka kumo ka
nioi zo izuru
iza ya iza ya
mi ni yukan

Translation:
Cherry blossoms, cherry blossoms,
Across the spring sky,
As far as you can see.
Is it a mist, or clouds?
Fragrant in the air.
Come now, come,
Let's look, at last!

GAME—THE MAGIC FOREST
Some students stand scattered in the room representing trees in a forest. They have a small percussion instrument to make a sound effect. A blindfolded person walks though the forest and the players prevent that person from bumping into them by making a sound.

NOTATION
Sakura

Writing melodic lines graphically: yarn game.

Children use a piece of yarn to represent a melodic line the teacher sings on the syllable "oo."

Teacher sings melodic phrases of Sakura. Students in pairs, one faces the board, the other behind him/her draws the melodic design on the back of the one facing the board who attempts to reproduce it on the board.

ENSEMBLE
Sakura

Students play the musical accompaniment on the Orff instruments. An improvised section in pentatonic is added after the song.

Music focus: Kumoi-joshi Japanese scale (pentatonic A-B-C- E-F)

DIORAMA—BLOW AND DAB TECHNIQUE (INK)

- Six students form a team; they lay out 6 pieces of paper in a row. As the teacher sings the melody line, the first person paints (with brush and ink) the landscape line on his/her paper. The rest do the same, one at a time, on their paper.
- When all six are finished, they place a thick drop of ink on their paper for the tree trunk.
- They blow through a straw to extend the drop, making a tree trunk go up the paper and blow it sideways to create branches.
- For the leaves, dab watery ink over and over with a cotton ball or a thin brush.

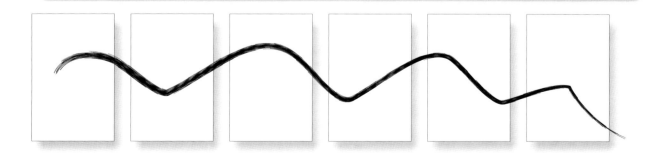

Eliza, 9 years old

Emmy, 9 years old

Henry, 9 years old

Sophia, 9 years old

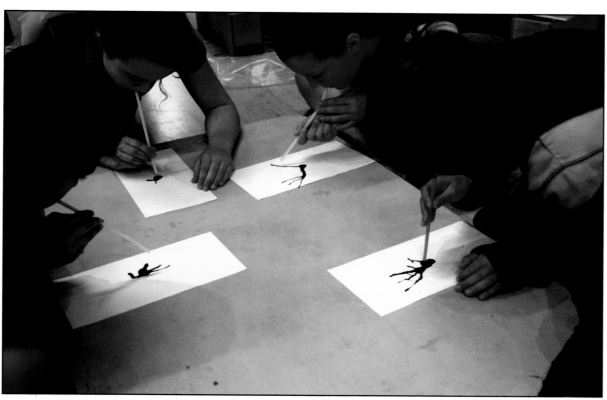

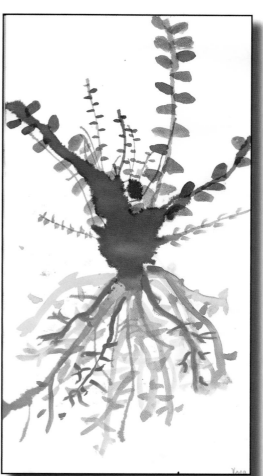

Noa, 11 years old

Yma, 11 years old

ENVIRONMENTAL ART
- Collect leaves or any natural material to make the art project.
- Organize the materials on a piece of paper to make a tree.
- Take a picture.

Suggested Children's books
Burnie, David. Kindersley, Dorling. *Tree*. London: DK. 2005.

Munari, Bruno. *Drawing a Tree*. Verona: Edizioni Corraini. 1978.

Holwitz, Peter. *The Big Blue Spot*. New York: Penguin Putnam Books. 2003.

Ehlert, Lois. *Leaf Man*. New York: Harcourt, Inc. 2005.

Mari, Iela. *L'Albero*. Paris, L'Ecole Des Loisirs. 2004.

Barbero, Marina and Fabrizio. *A Tree is...* Italy: B Edizionidesign. 2007.

Silverstein, Shel. *The Giving Tree*. New York: Harper Collins. 1964.

LIMERICKS

The graphic above represents the distinctive scheme of the limerick, a poetic form popularized in the 19th century by Edward Lear. Limericks are simple, short and humorous. Like the Cuban décimas, the African-American dozens and the Moroccan zajal, they are easy to compose and improvise by following this simple rule:

- Line 1, 2 and 5 have seven to ten syllables and need to rhyme with one another.
- Line 2 and 4 have five to seven syllables and need to rhyme with one another.

The limerick packs laughs anatomical
In space that is quite economical,
But the good ones I've seen
So seldom are clean,
And the clean ones so seldom are comical.
—OGDEN NASH

Writing limericks in music class is a new project in my repertoire for the upper elementary students. I use them to introduce short, improvised pieces in 6/8 meter performed with a particular instrument that will be recorded on our school CD. The 4th and 5th graders create the poems and pieces for the preschoolers to listen to; it helps them identify and learn the names of the instruments.

"Once I start making rhymes like this I keep doing that the whole day. It gets stuck in my brain and everything I think of goes in that rhythm!" (Eliza, 10 years old)

LIMERICKS

Sofía López-Ibor

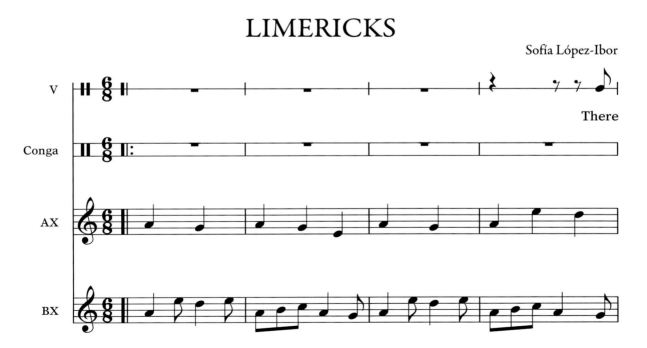

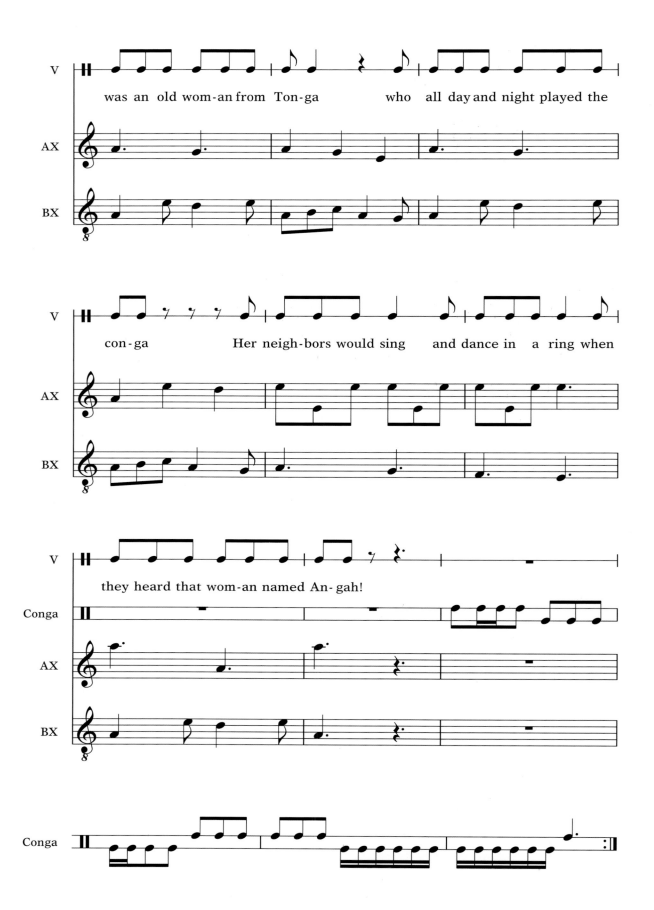

was an old wom-an from Ton-ga who all day and night played the

con-ga Her neigh-bors would sing and dance in a ring when

they heard that wom-an named An- gah!

GRAPHIC SCORE: SMALL PERCUSSION

- Represent the limerick beat scheme with small percussion instruments on the floor.
- Use a louder instrument for the accented beat.
- Have the students perform the rhythmic patterns with 2 vocal sounds, e.g.: Ra Ta Ra Ra Ta Ra Ra Ta....
- Give assorted percussion to the participants. Have them perform the rhythmic piece following the structure shown on the score.

LANGUAGE

Read several limericks to the students and notice the rhythmic and rhyming patterns.

> There was a young girl from Tralee,
>
> Who ate an old boot for her tea,
>
> At once she got sick
>
> So the doctor came quick,
>
> But the laces were all he could see.

- Students choose a classroom instrument as the topic for the poem.
- Students (individually or in pairs) repeat the limerick and then improvise a short piece with the instruments.

Limericks by Fifth Graders

There once was a lady in Peru
Who always forgot her left shoe.
She tripped on a drum,
Then fell on her bum,
And that's why she cried ¨Boo hoo¨!
 BY EMMY AND SOPHIA

There once was a Norwegian boy
Whose name was Fredrick McCoy.
He played the piano,
With a young soprano,
Until they woke up his dad Roy
 BY JOSH AND ELIAS

There was a young boy in a bar
Who never could play the guitar.
When he played he was hit,
By a maid named Marguerite,
And she said he would never be a star.
 BY HENRY AND ARJUN

My sister was never alone
When she played her bass xylophone
Her sound was so pretty,
Her music so witty,
That she played for her friends on the phone.
 BY SOPHIE AND DIMITRI

There was an old lady from Kimball
That every day played the cymbal
She played in a store,
While reading her score,
And played really loud all the symbols
 BY ROBERTO AND SONJA

ORFF ENSEMBLE

- Students learn the bass part first and identify the scale and the meter of the piece. Focus: 6/8 Aeolian.
- Find rhythmic and melodic ostinati to add to the piece.
- Add the text as a speech piece over the instrumental.
- Improvise or compose a rhythmic piece with the instrument mentioned in the limerick.

COLLAGE
Illustrate the limerick.
- Students choose clippings to make a collage illustration of the limerick.
- The image should show the instrument as the basic motif.

Bianca, 10 years old

Jocelyn, 10 years old

Elias, 10 years old

Elias, 10 years old

Chaya, 10 years old

Vanessa, 10 years old

Jack, 10 years old

Elena, 10 years old

Suggested Children's books

Lear, Edward. Domanska, Janina. *Whizz!*. London: Hamish Hamilton. 1974.

ROMBO ROMBOIDE

"Let no one who is not a geometer enter here"
—PLATO

Plato posted his admonition above the door to his academy to tell his students that only those capable of learning geometry could learn reasoning and philosophy. Geometry is part of every math curriculum and cognitive training; it teaches logic, analysis, reasoning, problem solving skills and spatial perception. It is a great subject to explore in art and movement class because all of these disciplines share a spatial sense and use similar parameters: size, shape, position, dimension (plane), symmetry and asymmetry. "Rombo romboide" is a traditional Spanish chant and clapping game that uses the name of the rhombus, a parallelogram that has the shape of a diamond. The origin of the rhyme has always intrigued me, and I suppose it originated with children wanting to remember some names of the basic figures in geometry.

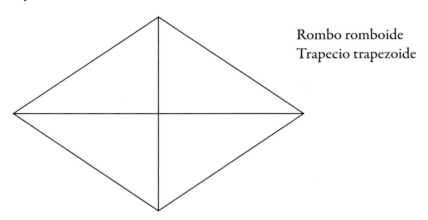

Rombo romboide
Trapecio trapezoide

The movement class proposed in this chapter uses sticks and elastic bands to explore basic geometric shapes. The children make all sorts of geometric shapes by stretching the bands among different players or body parts while recognizing the figures and the relationships among them. Instead of a "hands on" activity this is a "full body on" learning process in which the students pursue an in-depth investigation, drawing ideas from practical experience.

"What education has to impart is an intimate sense for the power of ideas, for the beauty of ideas, and for the structure of ideas, together with a particular body of knowledge which has peculiar reference to the life of the being possessing it". [*]

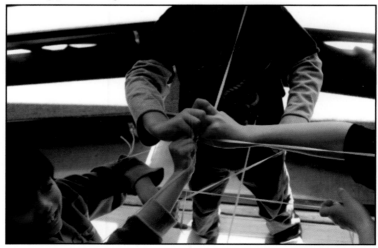

[*] Alfred North Whitehead. *The Aims of Education*. P. 23. New York, A Mentor Book. 1929.

ROMBO ROMBOIDE

Spanish Rhyme
arranged by Sofía López-Ibor

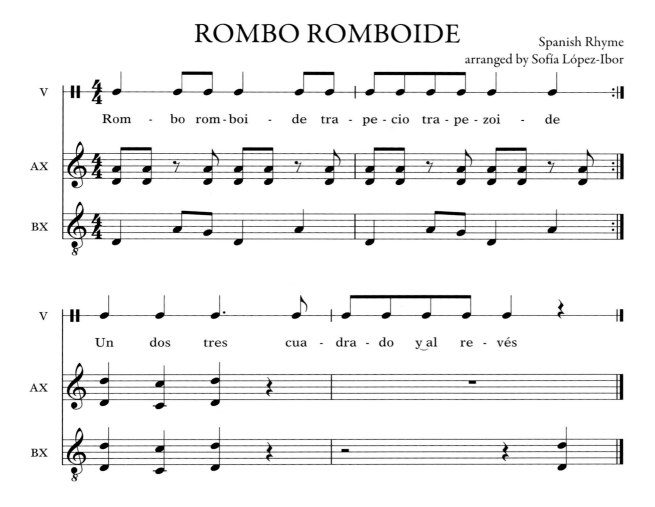

SPEECH

Chant the rhyme exploring:

- Dynamics
- Tempo
- Timbre
- Meter changes

CLAPPING GAME

- Students march around the room chanting "Rombo romboide trapecio trapezoide."
- Then they face a partner and create a geometric shape with a partner.

MOVEMENT

Working with elastic bands, have the students explore geometric concepts, identify figures, count the sides and compare vertices.

- Individual exploration: students make as many bi-dimensional geometric shapes as they can, stretching the elastic and holding it with arms, legs, hands, head, etc.
- With a partner: make tri-dimensional shapes.

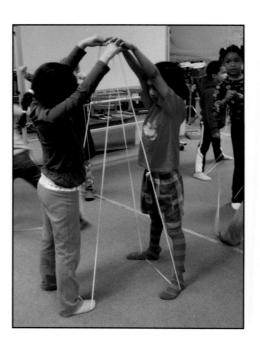
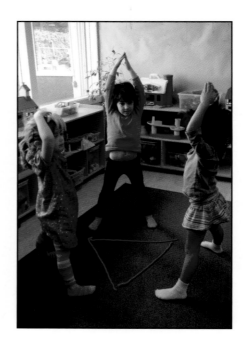

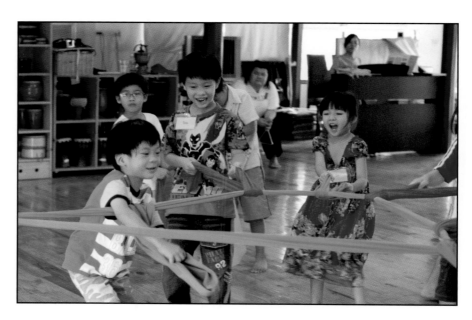

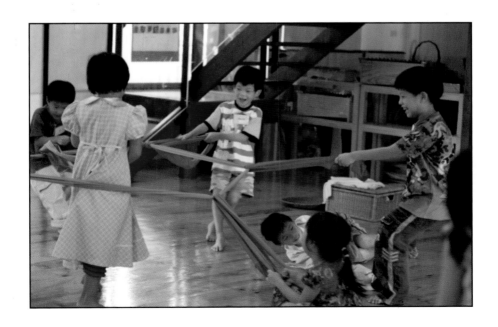

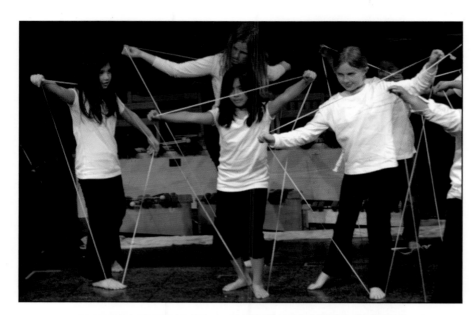

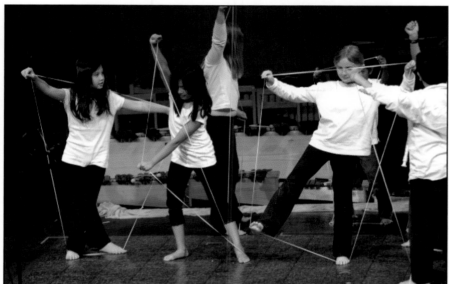

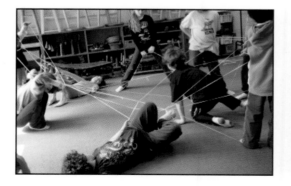

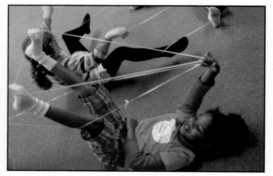

MOVEMENT CANON

- Have the students form trios.
- The first person says "My teacher told me to make this!" and makes the first shape.
- Then the first person says "My brother told me to make this!" and he/she makes a new shape while the second person copies the first shape.
- When the first person says "My auntie told me to go make this!" he/she makes a third shape while the third person in line makes the first shape and the second the second shape.
- Then the first person repeats the first shape three times until everyone is making the same shape.
- This movement canon can be done with 3, 4 or more players.

SMALL PERCUSSION

- Choose instruments for playing the rhythm of each word to create an interesting texture:
 Rombo: hand drum
 Romboide: claves
 Trapecio: maracas
 Trapezoide: triangle
- Classify the instruments according to their shape.

GEOMETRIC COMPOSITION: COLLAGE

- Cut geometrical figures.
- Make a composition by gluing them to a contrasting paper.

Buddhasuda, 5 years old

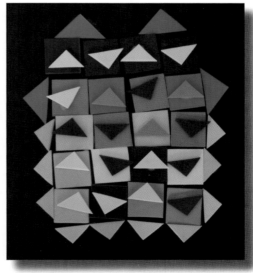

Suwee, 5 years old

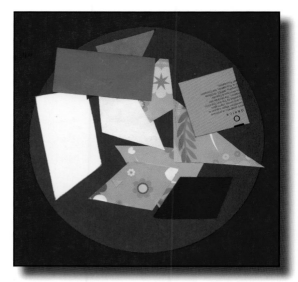

Paula, 8 years old

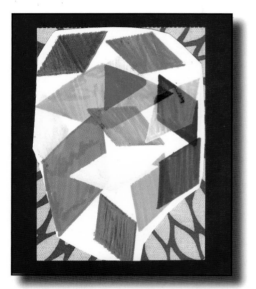

Rosa, 9 years old

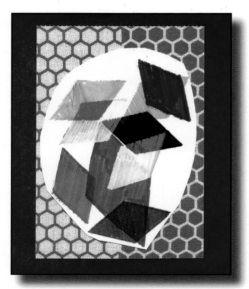

Rui, 10 years old

Jack, 6 years old

GEOMETRIC COMPOSITION WITH STICKS

- Students make geometric shapes with sticks.
- Glue sticks to paper and color the figure.

Omar, 3 years old

Mariza, 3 years old

Quinn, 3 years old

Elias, 3 years old

Nina, 3 years old

COMPOSITION

Form small groups to create geometric figures with chopsticks. Students add sticks one at a time.

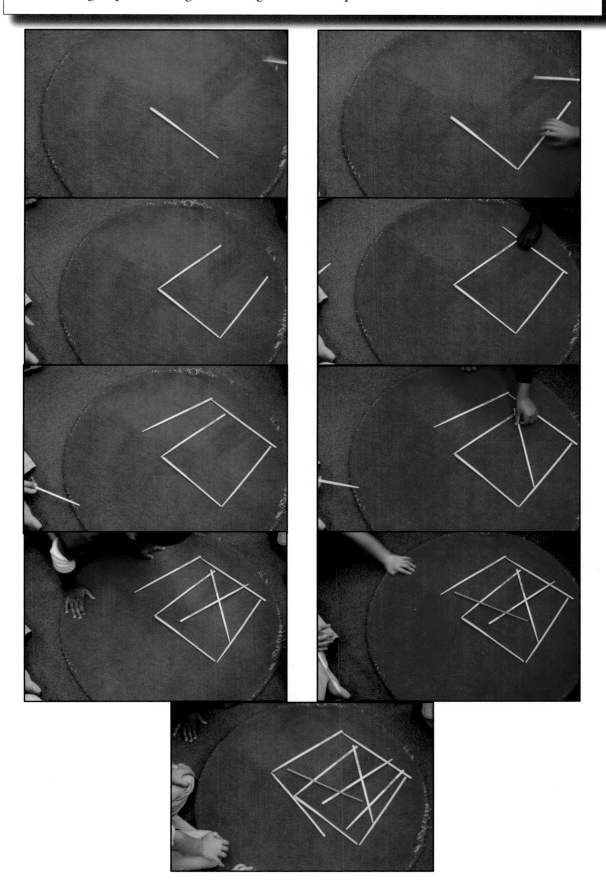

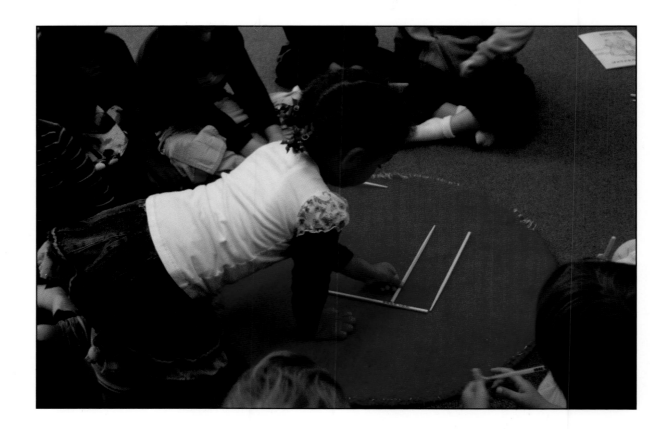

Suggested Children's books

Hoban, Tana. Shapes, *Shapes, Shapes*. New York: Greenwillow Books. 2001
Micklethwait, Lucy. *I Spy Shapes in Art*. New York: Greenwillow Books. 2004.

MOVEMENT SEQUENCE

The movement theme we explore in this chapter concerns body shape, which children call "statues." The goal of the lesson is to observe a movement sequence and reinforce the kinesthetic memory. As an inspiration for the class, I use simple animation toys to show the students how movements relate to one another in a series.

Phenakistroscope

A 19th Century animation game in the form of a spinning disc mounted on a handle. The viewer sees the images on the disc on a mirror through small slits.

Zoetrope

Animation game in which a strip of pictures spins in a cylinder. As the wheel turns the viewer looks through thin slits to see the figure in motion.

Praxinostrope is a variation of the same toy with a mirror cylinder.

Thraumatrope

A disk or card has a picture on each side and it is attached to two pieces of string or a stick. When twirled quickly the two figures appear to combine.

Thraumatrope 2

This works with a similar effect as the thraumatrope. The figures in two superimposed papers appear to combine when you move the first one by rolling it in and out fast with a pencil.

Flip book

The pictures in a flip book vary gradually from page to page. The images appear to move when you turn the pages rapidly.

WORKING WITH TOYS

- Provide one or more of the animation games for the students to play with (Phenakistroscope, Zoetrope, Praxinostrope, Thraumatrope and Flip book)
- Ask questions to help them discover what causes the image to move.
- Observe one of the insert strips of the zoetrope. Use it as an image for movements in a sequence.

MOVEMENT

Statue game

- Use a drum to accompany the students in a run and freeze game.
- When frozen, ask the students to form a shape, e.g., wall-like, ball-like, and pin-like.
- Try shapes in three different levels: low, medium and high.

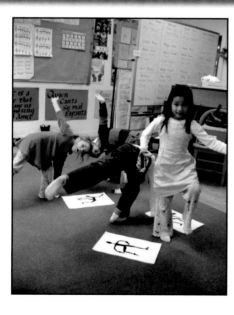
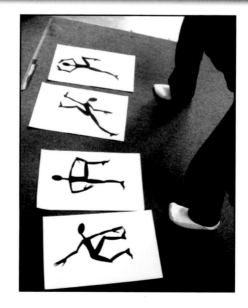

MOVEMENT SEQUENCE

- Divide the students into "stations" around the room with enough space to move. Small groups create a movement sequence.
- Move from one shape to the other with different "effort" or "dynamic" qualities:
- Moving fast from the first to the second statue.
- As above but with a locomotion movement in between.
- Move from one to the other lightly, like floating.
- Try the opposite, fast and strong.
- Move quickly, from one shape to another.
- Slow motion with sustained energy.

CONNECTING SEQUENCES

- Once the sequence is practiced, the groups share them with the rest of the class.
- Groups rotate to the next "station" to learn the sequence created by others.
- Traveling to the next station should be a smooth transition in the final performance (gliding, turning, spinning, jumping, moving in slow motion...)

POTATO PRINTS: FIGURE SEQUENCE

- Cut potatoes into small and large pieces to make the head, body, arms and legs of the figure.
- Students make a figure by dipping the potato stamps onto paper with gouache paint.
- Students should try to make a figure in a "neutral" standing position and an interesting shape (arms up, reaching down, etc.)
- Combine several figures to create a sequence.

Henry, 10 years old

Sam, 10 years old

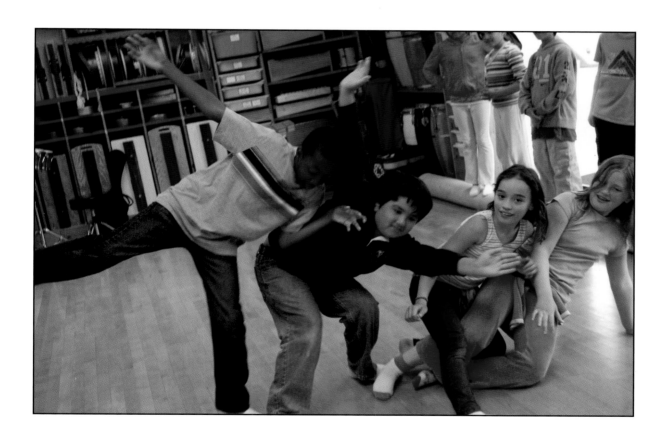

ALUMINUM FOIL SCULPTURE

- Using a piece of foil, students make a human figure in a particular posture.
- Use clay for the pedestal that holds the figure.
- Organize the figures to create a movement sequence.

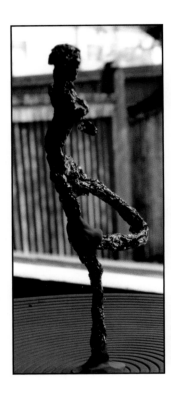
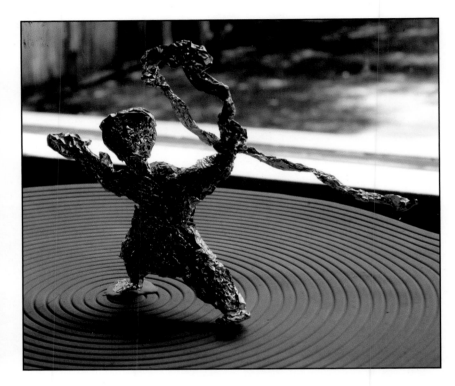
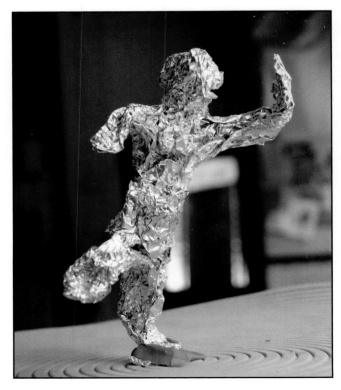

Suggested Children's books

Cooper, Elisha. *Dance*. New York: Greenwillow books. 2001
Haring, Keith. *Ten*. New York: Hyperion Books. 1998.
Otsuki, Akane. *He Meets*. Tokyo: Fukuinkan Shoten Publishers. 2004.
Harring, Keith. *Dance*. Boston, New York: Little, Brown and Company. 1999.

STORYBOARDS

In this chapter I propose creating a storyboard based on a song text, which the children represent graphically. This is especially useful for remembering songs or rhymes that have many verses or a complex story. The examples here are two Mother Goose rhymes: "Simple Simon" and "A Farmer Went Trotting," and a song by Argentinean composer Maria Elena Walsh, "La vaca estudiosa" (The Studious Cow). The final idea in this part of the book is interpreting a comic strip in movement or creating movement canons based on comic images.

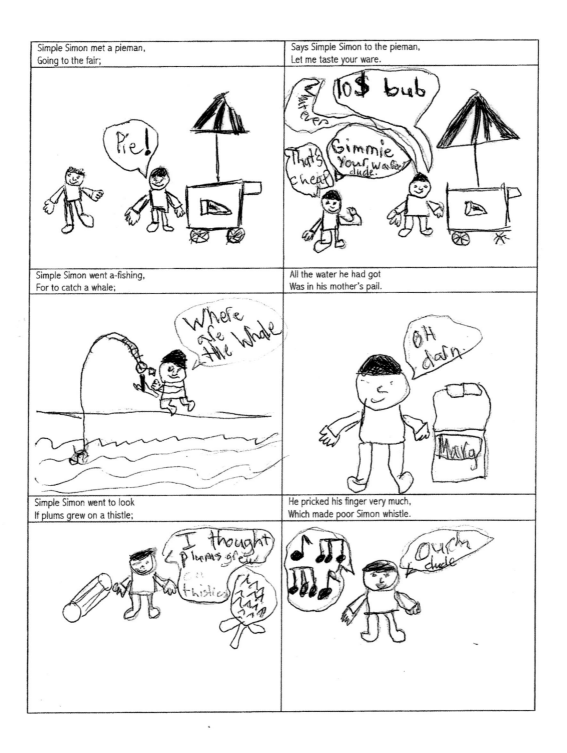

SIMPLE SIMON

Mother Goose
arranged by Sofía López-Ibor

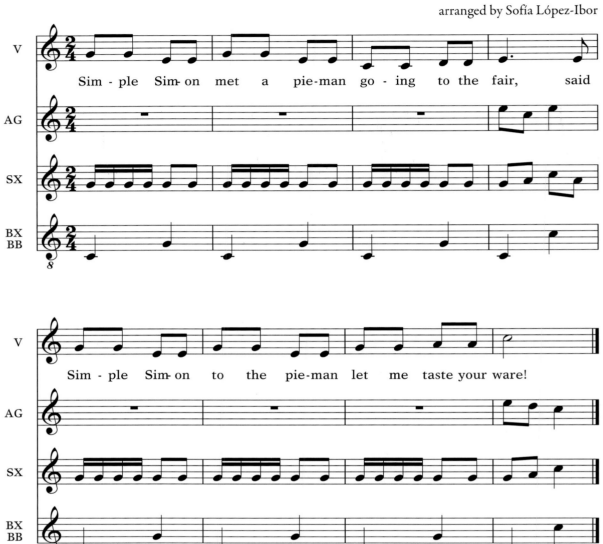

Sim - ple Sim-on met a pie-man go - ing to the fair, said

Sim - ple Sim-on to the pie-man let me taste your ware!

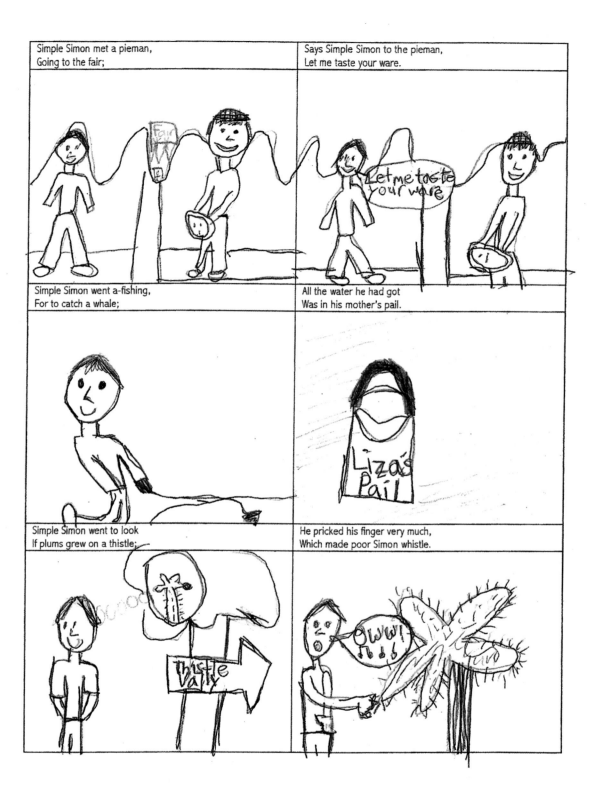

SIMPLE SIMON

- Have students think of their favorite pie. They make a drawing of the pie and notate the rhythm.
- Perform the first verse of the rhyme and include four "pie motifs" spoken as a B section of the piece, e.g., apple pie, plum pie, pear pie, lemon pie.
- Ask the students to find a melodic motive for each pie.

Blackberry Pie

Apple Pie

Strawberry Pie

Lemon Pie

A FARMER WENT TROTTING

Have the students perform the rhyme:

- As a pantomime exercise accompanied by sound effects.
- As a speech piece with pitched percussion.

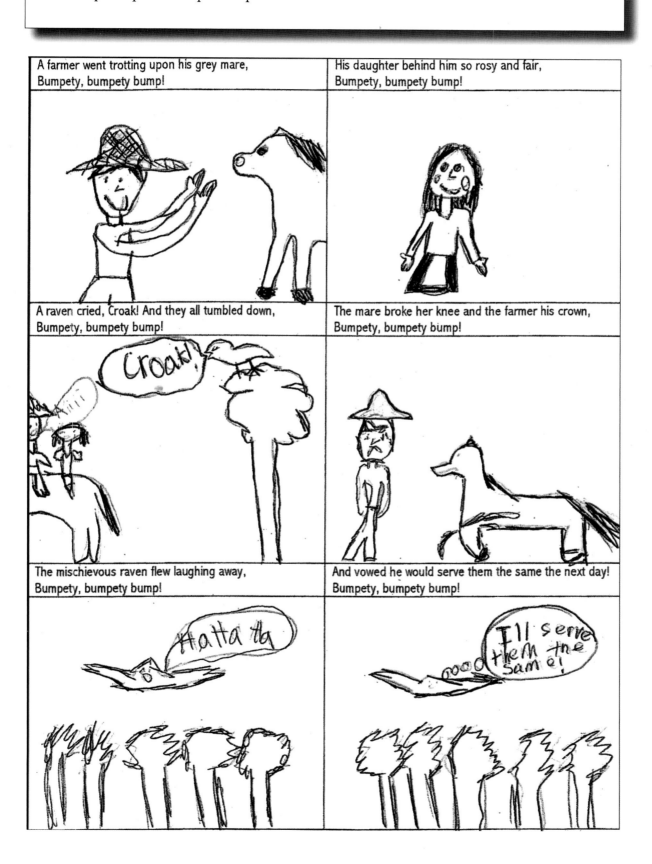

A FARMER WENT TROTTING

Mother Goose
arranged by Sofía López-Ibor

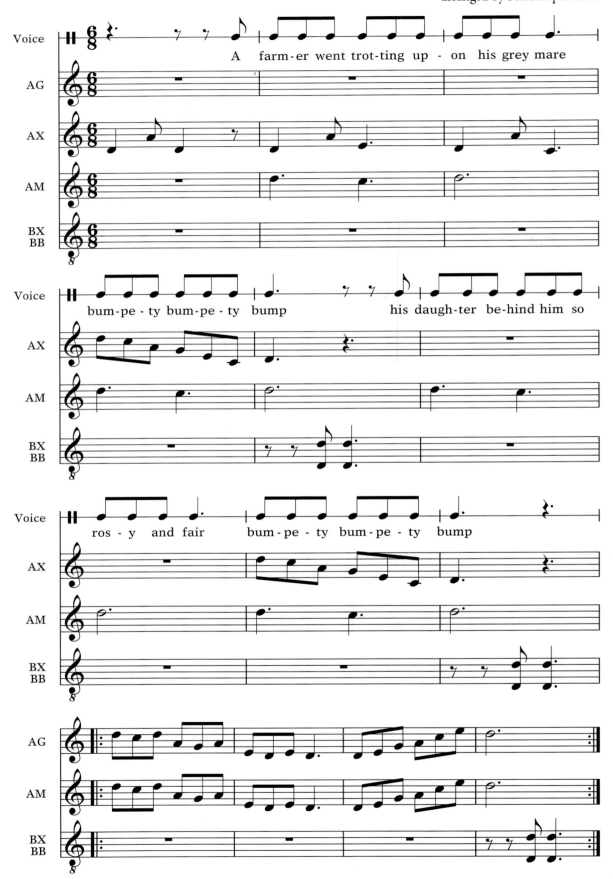

Voice: A farm-er went trot-ting up - on his grey mare

bum-pe - ty bum-pe - ty bump his daugh-ter be-hind him so

ros - y and fair bum-pe - ty bum-pe - ty bump

LA VACA ESTUDIOSA

Maria Elena Walsh

Ha - bi a u - na vez u - na va - ca en la Que - bra - da De Hu - ma -

hua - ca_____ Co - mo e - ra muy vie - ja muy vie - ja es - ta - ba sor - da

du - na o - re - ja_____ Y a pe - sar de que e - lla e - ra a - bue - la

un di - a qui - so ir a la es - cue - la_____ se pu - so u - nos

za - pa - tos ro - jos guan - tes de tul y u - nos an - te o - jos

Habia una vez una vaca
en la Quebrada de Humahuaca
Como era muy vieja muy vieja
estaba sorda de una oreja
Y a pesar de que ella era abuela
Un dia quiso ir a la escuela
Se puso unos zapatos rojos
guantes de tul y unos anteojos.
La vio la maestra asustada
y dijo -estas equivocada
Y la vaca le respondio
¿Por que no puedo
estudiar yo?
La vaca vestida de blanco
se acomodo en el primer banco
Los chicos tirabamos tiza
Y nos moriamos de risa
La gente se fue muy curiosa
A ver a la vaca estudiosa
La gente llegaba en camiones
En bicicletas y en aviones
Y como el bochinche aumentaba
En la escuela nadie estudiaba
La vaca de pie en un rincon
rumiaba sola la leccion
Un dia toditos los chicos
se convirtieron en borricos
Y en ese lugar de Humauaca
La unica sabia era la vaca

Translation:

Once upon a time there was a cow in Quebrada de Humahuaca.
She was so old she was deaf in one ear.
Although she was a grandmother, one day she wanted to go to
 school.
She wore her red shoes, lace gloves and glasses.
The teacher looked at her with panic and said- you are wrong!
And the cow responded: Why can't I study?
The cow in her white dress sat on the first bench
The kids threw chalk at her and laughed.
Curious people came to see the studious cow
People arrived in trucks, bicycles and airplanes.
As the scene got more excited no one paid attention to the lesson
Standing in the corner by herself the cow digested the lesson
One day all the children turned into donkeys
while the only wise person in the school was the cow.

Emanuel, 7 years old

LA VACA ESTUDIOSA (MARIA ELENA WALSH)

Maria Elena Walsh is one of my favorite poets for children. Learning the text with non-Spanish speaking kids is a challenge so I like to introduce the story with an improvised opera in which the characters have to improvise lines and melodies to show the action.

Ellie, 7 years old

Diego, 7 years old

Belen, 7 years old

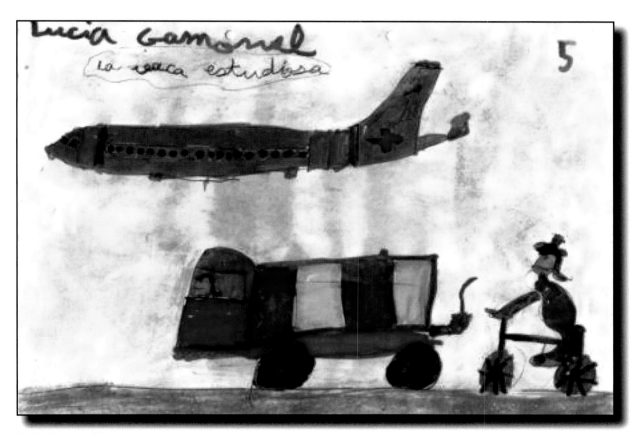

Lucia, 7 years old

WEAVING

Weaving is one of the most ingenious and universal of human inventions. It is simply the interlacing of material by itself or (natural grass, yarn, thread, paper, etc.) or sometimes with a support or loom. We really don't know where the idea came from—maybe we just copied what was already in nature.

In this section, we will see how the basic weaving concept can be explored not only in art projects but as a dance activity in which the students experience the pleasure of interlacing and creating a big piece of "fabric." One of the most exciting versions of the "weaving" dance I ever had was in one of my workshops at the Jittamet School in Bangkok, Thailand. The teachers used natural dye to color long pieces of cotton that created a gorgeous pattern. We sang and danced as we created a human loom, we wove the pieces in and out and created a beautiful blanket in a process that unfolded seamlessly, simply following the impulses and ideas from the participants. We continued by making the woven piece tight and also opening the spaces in between, allowing us to go under and over it when laid on the floor.

Many traditional games feature weaving as the main event: The Big Ship Sails, Wind Up the Bunkin, Go In and Out the Window, Bluebird Through my Window, etc. In all of them the children can experiment by going under each other's arms while leading a line, etc. There are also numerous dances, like the May Pole, in which the dancers create beautiful woven patterns with long strings. When working with long pieces of fabric, a chant could be used to accompany the weaving process:

> Go over
> > Meet with a clover
> Go under
> > Meet with a blunder
>
> —MOTHER GOOSE

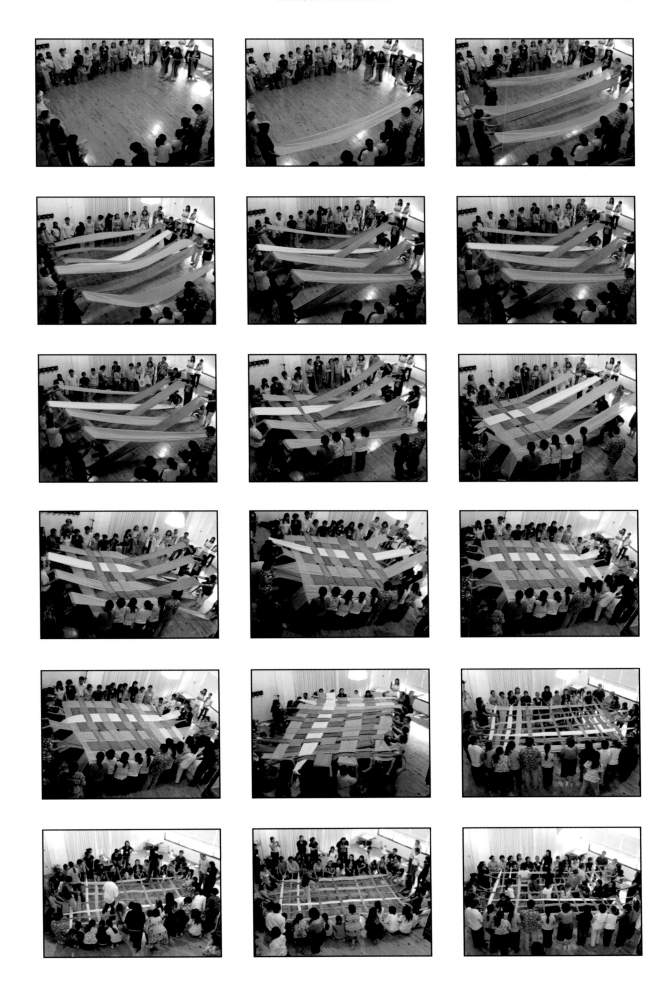

MOVEMENT

Have students experience weaving in and out of a line in different ways:

- One person at a time
- Follow in a line
- 2 lines weave at the same time
- Make arches with the arms
- Go under the legs.

PAPER WEAVING

- One piece of construction paper is chosen for the "warp." Cut full length slits leaving an inch at either length of the paper.
- The "weft" lines are cut-out strips of paper. Weave them across the piece of paper over and under the slits.

Carla, 6 years old

Carla, 6 years old

MUSICAL SCORE

- A weaving of paper can become an interesting music score if you add some symbols to each square.
- Read the symbols from left to right, right to left, down, up. Read them in any direction, diagonally or zig-zag.
- Make the lines in the weaving patterns moveable so that you can readily change the rhythmic sequence.
- Assign each line to a different instrument or instrumental group. Add other groups to create a layered texture.

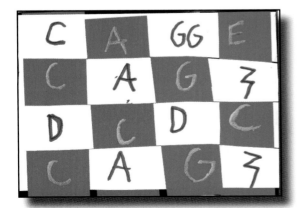

Jack, 8 years old

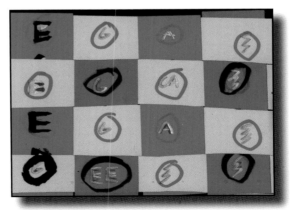

Emanuel, 8 years old

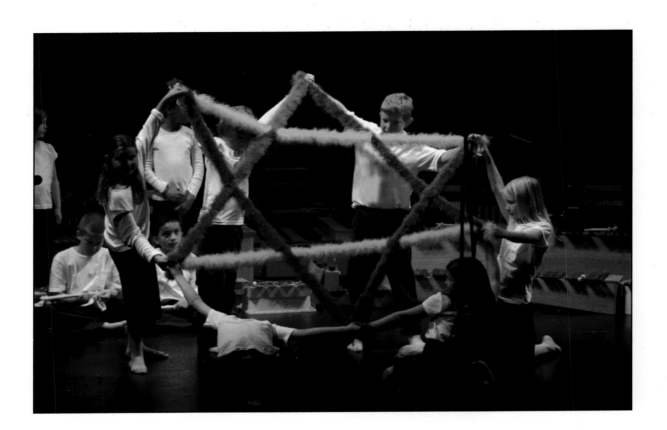

GRAPHIC NOTATION

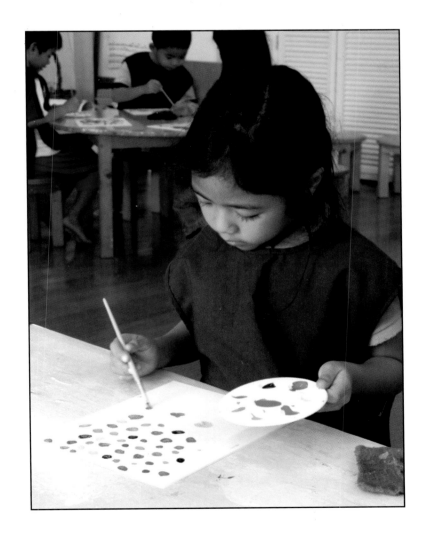

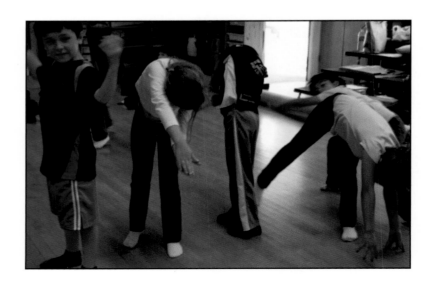

GRAPHIC NOTATION

Introduction

"I can't understand why people are frightened of new ideas. I'm frightened of the old ones."

—JOHN CAGE

Graphic notation, a system of symbols and drawings, has been used by contemporary composers such as John Cage, György Ligeti, Krzysztof Pendereki, Karlheinz Stockhausen, George Crumb and others to convey information about a piece of music. The system is also widely used in the world of dance by contemporary choreographers as a method of documentation and reconstruction of movement. Visual imagery plays an important role in creative thinking in music and it is a concept widely used in education.

My first encounter with unconventional notation was during my music pedagogy training in Spain with teacher Fernando Palacios. It was an eye-opening experience! I had a great time creating pieces, drawing the sounds in recordings that were new to my ears, but it was hard for me to figure out how I could apply such practices in the class. It was only after leading a series of graphic notation sessions with 10 year olds, that I recognized the power of this kind of work.

Working with graphic notation is an intense creative process and a wonderful experience for students to share. Since there is no "correct" way of creating or performing the pieces, the children need to negotiate, discuss and accept each other's ideas. When children are playing instruments they are thinking about melodies, rhythms, patterns and not about sound in a raw sense. Here, sound becomes an idea in itself, interesting to explore, observe, collect, analyze, compare and play with. Therefore, graphic notation widens the stylistic and linguistic boundaries of music. (It extends the semiotics and semantics of music.)

Graphic Notation Ideas

Creating messages with symbols is a fundamental aspect of communication

This work brings us closer to the nature of music and sound

The process of creating the score is in close contact with the musical idea

The technique and the material of the painting affect the sound

Scores are open systems. They can be recreated many times

The material used to create the score produces a sound or movement idea

Contemporary paintings and folk art can be used as a graphic score to be interpreted in music or movement (e.g., Kandinsky, Calder, Miro, etc.)

The type of graphic used by the composer conditions the expressive results of the score

Here is the process I've used for realizing these scores. The students:

- Choose the instruments and performers. (The score can be for small percussion, found instruments, xylophones, recorder or vocal ensemble.)
- Give the piece a title.
- Explore the interesting sounds the instruments can make.
- Create a key for the symbols in the score (representing pitch, dynamic, effects...).
- Decide in what order the symbols will be played. It could be a variety of micro-events or a traditional form such as rondo.
- Determine how the score will be read (from left to right, right to left, top to bottom or vice-versa, random...).
- Think about how the piece would sound played by an ensemble other than the classroom instruments.
- Perform the piece, listen to all groups in the class and comment.

THE ALPHABET

SOUND EXPLORATION

Students in a circle explore the first sound of their name.

- Each person makes a motive with the sound. All echo.
- One person in the centre of the circle conducts a piece inviting sounds (using ostinati, patterns, echos, etc.).
- Walk around the room and find people that have the same first sound in their name. Re-group in the circle. Each group improvises a short musical piece with that sound.

BREATHING RONDO

Sofía López-Ibor

- Teach the rondo theme to the class.
- In-between, improvise a new section with letter sounds.

RONDO THEME

Sofía López-Ibor

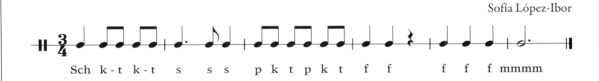

Sch k - t k - t s s s p k t p k t f f f f f mmmm

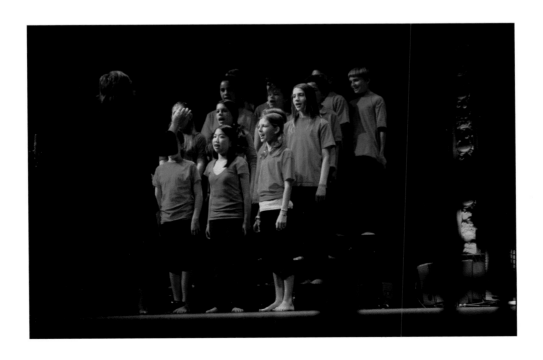

El Melos de las Letras by Fernando Palacios[*]

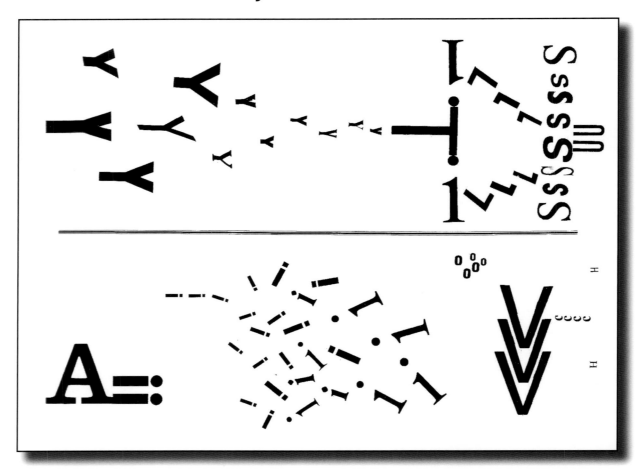

[*] © Fernando Palacios. *Piezas Graficas Musicales Para la Educación*. Gijón. Fundación Municipal de Cultura. With permission.

Mouth Music One—A Graphic Piece by Wolfgang Hartman

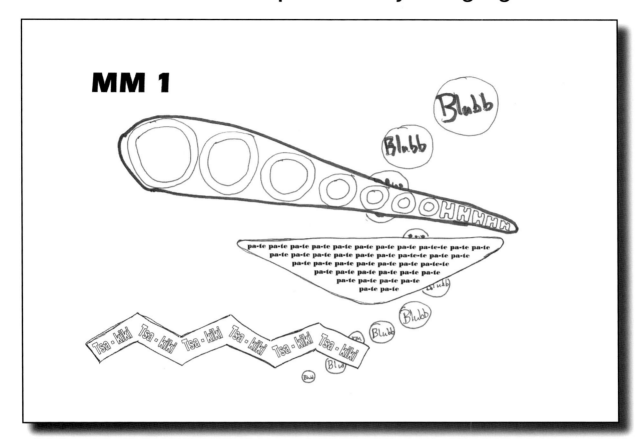

The piece MM1 (Mouth Music One) can be developed in four steps:

 Step 1–Every one of the four types of sound should be experienced first individually.

 Step 2–Put the four types of sound in an order and the whole group sings/speaks in unison.

 Step 3–Use the "pa-te" part as an intro and do the rest in a three-part canon.

 Step 4–Find a more complex form and add improvised parts.

MM1 also can be a stimulus to create MM2, MM3…

<div align="right">WOLFGANG HARTMAN</div>

CREATING THE GRAPHIC SCORE

- Use letter stamps or cut-out letters to create your score.
- Students in a small group create the symbols, and decide how to perform them.
- The piece is performed in front of the class. Students add comments and suggestions for improvement in a second performance.

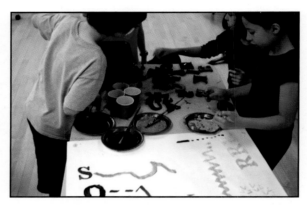
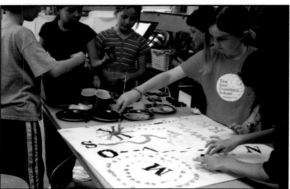
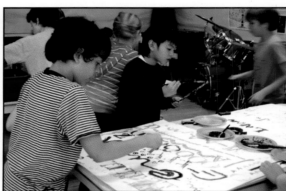

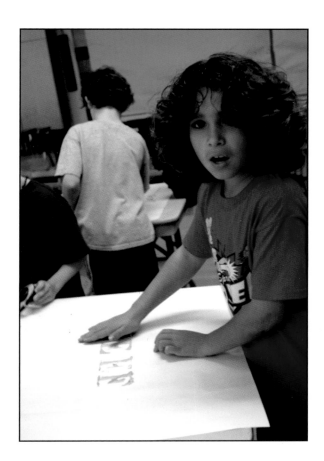

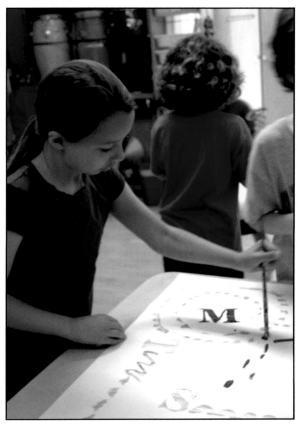

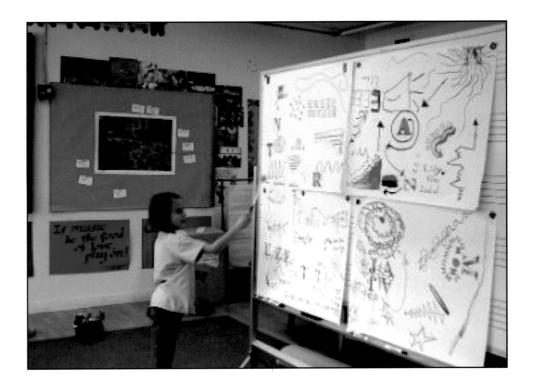

DOTS AND LINES

"A line is a dot that went for a walk."
—Paul Klee

600 Black Spots, a book by David Carter, is the inspiration for this lesson in movement and graphic notation. My students were delighted by the movement ideas of this pop-up book.

MOVEMENT 1

- Students standing in their own space draw dots in the air in slow, medium and fast tempo. They draw them up, down, to the left and right. They draw dots with their finger, hand, knee, toe, nose and head.
- Still in their own space they use their whole body as a paintbrush to make lines and squiggles.

MOVEMENT 2

- Students draw on paper what they have "painted" with their body. They talk about their drawings with a partner.
- Partners exchange drawings and practice a movement routine using the common space.

MOVEMENT 3

After looking at David Carter's *600 Black Spots* students choose a particular scene to represent in movement.

PERFORMANCE

Students watch each other's performances and suggest a possible order of the pieces. They give feedback to other groups:

What part of the piece was not clear? What should we keep? How can we improve the piece?

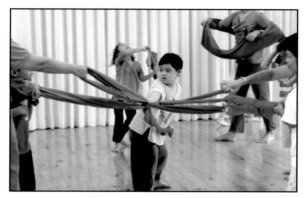

Suggested Children's books

Hughes, Langston. *The Book of Rhythms*. New York: Oxford University Press. 1995

Steig, William. *C D C ?*. USA: Melanie Kroupa Books. Farrar, Straus and Giroux. 1984

Micklethewait, Lucy. *I Spy: An Alphabet in Art*. New York: Mulberry Books. 1992.

Gregoretti, Paola. *Alfabeto Diavolino*. Trieste: Einaudi Ragazzi. 2008.

Munari, Bruno. *Alfabetiere*. Torino: Giulio Einaudi. 1960.

Seuss, Dr. *ABC*. New York: Random House. 1963.

Hefter, Richard. Moskof, Martin Stephen. *A Shuffle Book*. New York: Golden Press.

Reynolds, Peter H. *The Dot*. Massachusetts: Candlewick Press. 2003

Juster, Norton. *The Dot and the Line*. New York: Random House. 2005.

Fox, Mem. Roshenthal, Marc. *The Straight Line Wonder*. USA: Mondo. 1977

Whitman, Candace. Wilson, Steve. *Lines that Wiggle*. USA: Blue Apple Books. 2009.

Johnson, Crocke H. *Harold and the Purple Crayon*. New York: Harper Collins. 1955.

Baker, Keith. *Just How Long Can a Long String Be?*. USA: Arthur A. Levine Books. 2009.

Munari, Bruno. *Viaggio Nella Fantasia*. Milano: Edizione Corraini. 1992

Carter, David A. *600 Black Spots*. USA: White Heat Ldt. 2007

IMBENGE

Imbenge are beautiful telephone wire baskets made by the Zulus of KwaZulu Natal, South Africa. They are woven so tight they can hold liquid and they include ancestral symbols for each group or family. Based on their traditional palm leaf baskets (ukahamba), the Zulus started making imbenge about 20 years ago. I first saw them at the de Young Museum in San Francisco and I was inspired by their circular designs and colorful spirals. The ideas collected in this example are a summary of the exploration of that theme with my nine-year-old students.

The main purpose of bringing imbenge to my class was to make connections between visual art and music. The students use the symbols appearing in the baskets to convey information about the performance of a music and dance piece. The hand drum is an excellent instrument to use while dancing and/or to accompany others while moving. We use a variety of dynamics and tonal variations as well as techniques other than the normal stroke, for example rubbing the skin, dabbing, flicking...

One of my favorite experiences as a teacher is to watch students in small groups plan a piece or a performance. What might look like chaos to an outsider (we often have several groups creating and practicing their pieces at the same time) is really a wonderful opportunity for the teacher to watch and listen.

PERCUSSION

Hand drum technique.

- Explore hand drum sounds: technique, timbre, dynamics and tone quality.
- On their own, students explore the various techniques and then share them with the group in an echo game.

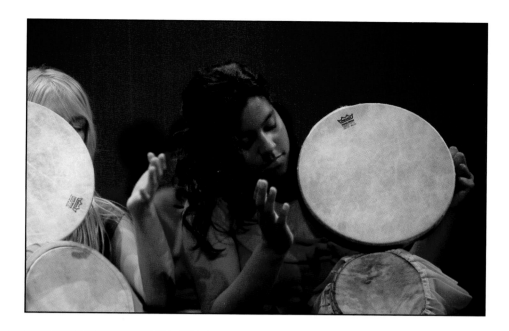

NOTATION

Observe the Imbenge images and connect them to the sounds previously explored. The following image could be represented by making a rubbing sound spiraling in and out on the drumhead with a crescendo.

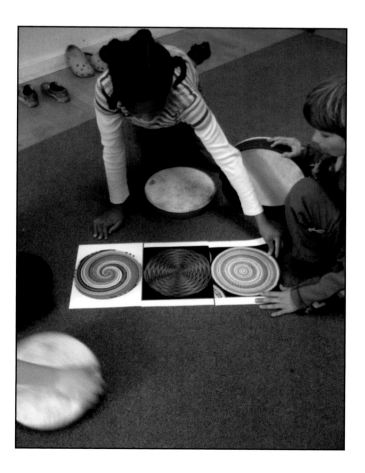

COMPOSITION

- In groups of four, students choose three Imbenge images of contrasting patterns and qualities.
- Invite them to discuss what they see and how it could be represented musically or in dance.
- Suggest they think about the form of the piece; encourage them to have a clear beginning and ending.
- Have the students listen to the performances and make comments; ask them about the highlight of the piece and what could be improved.

MOVEMENT
The Imbenge images can also inspire movement:

Spiraling in the air with one arm, one leg....

As a floor pattern for a locomotive movement, e.g., run in a spiral.

IMBENGE PAINTING: TEMPERA

- Show pictures of Imbenge baskets and have students trace an oval or circle on a piece of paper.
- Then they think about what shapes to use for the inside: spirals, circles, tessellating shapes, etc.
- Color inside of the circle first.

Antonio, 9 years old

Tessa, 9 years old

Abby, 9 years old

Niza, 9 years old

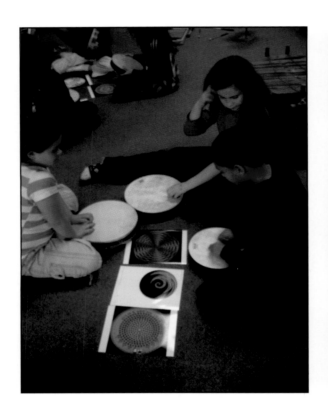
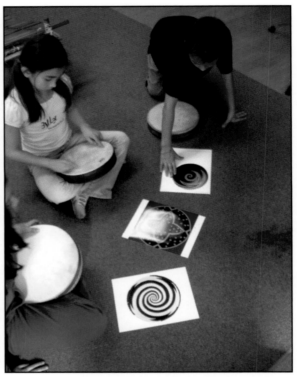

CONNECTING IMAGE TO MUSIC, ART AND POETRY

CONNECTING IMAGE TO MUSIC, DANCE AND POETRY
Introduction

The Renaissance was a high point in Western culture, characterized by the ideal of integrating diverse areas of thought within each individual. The ideals of the Renaissance resonate with the Orff Schulwerk philosophy and are realized in its practice of forming musicians that dance, dancers that paint and painters that sing. Here is a quote from the Renaissance philosopher, Jan Comenius, considered by some to be the father of enlightened pedagogy:

> "Great Didactics is a general art of teaching everyone everything. And teaching reliably so that the result must come. And teaching gently so that neither the teacher nor the pupils feel any difficulties or dislike; on the contrary, both find it very pleasant. And teaching thoroughly, not superficially, but bringing everyone to a real education and noble manners." [*]

To that statement I would add: "Great learning is an art wherein everyone discovers everything, exploring fundamental ideas and having a great time." "Great learning" happens when students:

- are excited and enjoying themselves
- use all their senses
- interact with the given information
- interact with each other
- help to decide what is really important to know
- connect with their feelings
- feel the motivation and excitement of the teacher

In the preface I have referred to the importance of the double perspective of making and perceiving art and music. In addition to developing creative work with the students, we can extend their experience by studying the works of the great artists. Encountering a work of art means coming face to face with it to see what ideas are there. This chapter describes how the painter's universe can be explored in music and movement class to promote meaningful learning. It gives some ideas of how to make looking at art an active, participatory experience.

[*] Palmer, Joy A. *Fifty Major Thinkers on Education*. USA: Routledge, 2001.

Active Looking

Art appreciation was never a hands-on experience during my childhood. Classes and visits to museums were based on transmitting a lot of details and memorizing encyclopedic facts. Not much discussion and thinking was involved and consequently not much "heart." How much do young students really need to know about the history and the biography of the artists? I propose circling around the painting and perceiving it in a rounder sense, developing a natural interest in visual arts.

David N. Perkins, one of the founding members of Project Zero at Harvard, describes four principles that we can apply to looking at art:

1. ## GIVE LOOKING TIME

 This principle reminds me of the advice my father gave me when I visited the British Museum for the first time as a teenager. Instead of walking hours in the museum and getting art-indigestion, we should choose a piece or two to study in detail and learn something about them. Browsing time through the museum galleries is always necessary before choosing what you want to look at in detail.

2. ## MAKE YOUR LOOKING BROAD AND ADVENTUROUS

 Explore with the five senses and use your Multiple Intelligences (Howard Gardner). Exercise the imagination by telling a story, composing music, creating another art piece, dancing, etc.

3. ## MAKE YOUR LOOKING CLEAR AND DEEP

 Take notes, document, research and compare to avoid superficial, fuzzy learning.

4. ## MAKE YOUR LOOKING ORGANIZED

 Describe, analyze and interpret the information. In a recent visit to the National Gallery in London I saw a teacher ask a group of children to close their eyes for a minute before looking at a painting. With a silent concentration, she prepared them to see the miracle of a Watteau landscape. Then she led the children into looking while covering one eye and then the other, gazing with the eyes almost closed, browsing up and down the painting, making a telescope with their hands. There are so many ways of looking.

In the chart on the next page, I am referring to painting, but all ideas can be explored with other artistic media as well. This is applicable to art pieces from all times and traditions and all ages too. The art pieces can be projected on the wall, shown in a poster format or smaller pictures for the children to handle individually. Always have the students look at the painting quietly for a couple of minutes.

I SEE, I THINK, I WONDER*	QUESTIONING	COMPARING	SITUATING
Lead a group discussion using the Project Zero thinking routine. The discussion will help the students make observations and draw conclusions about the ideas in the painting, the appearance of things, structure and feelings.	If you could meet the artist, what questions would you ask about the painting?	Think about other works of art that have similar qualities. Think about characters in picture books that remind you of the painting.	In what kind of building do you think this painting should be? If this work was hanging in a restaurant, what kind of food would they be serving?
GETTING TO KNOW YOU	**GETTING INSIDE**	**TITLE**	**PUZZLE-MATCHING GAME**
If there is a character in the painting, how does it compare to you? What is the character looking at? What do you think the character is thinking?	What do you hear? Smell? See? What is the temperature? What time is it? What season? Who is with you? What are they like?	Give a title to the painting.	Cut the image into pieces and reconstruct it. Cut out some pieces from the painting and let the students find where their piece belongs.
I SPY WITH MY LITTLE EYE— COUNTING	**PERIPHERAL VISION**	**GEOMETRY**	**SOMETHING MISSING OR EXTRA**
Looking for details, the hidden secrets. Count shapes, animals, musical instruments, people...	If the painting was widened, what else would you see?	Looking at the relations between objects in the painting	What do you think the painting is missing? What other shapes or objects would you add or delete?
START AGAIN	**TREASURE HUNT**	**MUSIC AND DANCE ANALOGY**	**STORYTELLING**
What part would you select to start a new painting?	Seek out hidden details or objects.	How does the painting sound? How would you dance it?	What's going on here? Tell the story you see in the painting.

* Gardner, Howard. *Project Zero*. Harvard University.

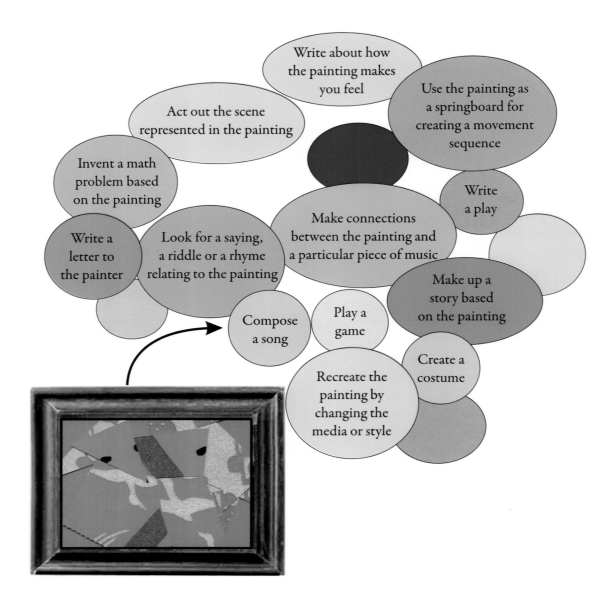

Write about how the painting makes you feel

Act out the scene represented in the painting

Use the painting as a springboard for creating a movement sequence

Invent a math problem based on the painting

Write a play

Make connections between the painting and a particular piece of music

Write a letter to the painter

Look for a saying, a riddle or a rhyme relating to the painting

Make up a story based on the painting

Compose a song

Play a game

Create a costume

Recreate the painting by changing the media or style

MOLAS

Poetry with Third Grade

Molas are a unique expression of folk art by the Cuna Indians in Panama and Colombia that depict every detail of their life. They are made by cutting slits and stitching together several layers of brightly colored fabric. They are used to decorate parts of the female costume.

This project began with a discussion applying with a "Project Zero" thinking routine based on the first mola.

Here are the student's comments:

I See	I Think	I Wonder
Lines	It represents an animal.	How much does it cost?
Angles	It is folk art.	Where did you buy it?
A square	It is very pretty.	What country does it come from?
A heart	The turtle is about to move.	If there are other examples, what
A turtle	It is not easy to make one.	other motives do they have?
Spirals	My mother would like it.	If it is painted, what are we doing
A labyrinth	It looks mysterious.	with it in class?
Dots forming lines		
Threads and fabric		
A brain		

Third grade students were asked to create a poem in 4/4 meter and work on a simple orchestration with small percussion.

POEMS BY THIRD GRADERS

The box had rocks
The monkey ate the fox
The pelican ate the monkey
And he got chicken pox.
 BY VEDA AND ALEXANDER

One two three
The fish said "yippee"
The pelican ate the fish
And the fish said "poor me"
 BY ANGELA AND BRISA

MIRÓ—"There Was a Little Magpie"

Creating a game with Fourth grade

- As the students enter the room a big slide with the painting is projected on the wall.
- The natural impulse of the children is immediately to comment on what they see.
- Give focus to the observation by leading the group with questions.

Does the painting remind you of any game we know?
"Darts"
"Aiming games, throwing a ball in the basket"
"Hula hoops"
"Running in circles"
"Circle game with one person inside?"
"Dancing in a round in circles like we did in chorus"
"It is like a big twirling skirt"
"It can have depth like a hole"
" Waves in a gong"
"Throwing a stone in the water"

After the brainstorming, the students were given the assignment of creating or re-creating a game of a dance form based on the painting that they could share with a class of five year olds. They could use any song or melody they had in their repertoire, but the goal was to invent a new activity for the Orff Class. The students had some time to experiment, to practice their game and to think about what the younger students would learn when doing their activity. Here is a description of the results:

Passing game by Nick, Arjun, Taylor
"Three players start the game of passing a stone to the right and take the next one. This represents the blue circle in the painting. Other players watch carefully how they do it. Then 3 other players join in a bigger circle (yellow). When the rest of the players have seen how the game is done they all join (red circle). The black dot can be someone singing the song or playing the steady beat on one instrument."

Singing a Round by Bianca, Emmy, Vanessa, Isabella
"We can sing a round in 3 parts. Each circle corresponds to one group, and each group moves walking in the circle while singing. For the Kindergarten students the song should not be difficult and we can help by having some fourth graders in each of the circles."

Hand drums by Elias, Henry, Chaya and Isabel
"The black dot is someone in the center playing a slow beat on a bass drum. Each of the circles has a particular rhythm (they meant rhythmic ostinato) and they have to play it while walking around but matching the beat of the bass drum. Blue circle goes first (ta tate ta ta), then yellow (ta ta ta rest) and then red (syncopa ta ta). Then they all switch places."

Game by Sam, Tyler, Jack and Nigel
"The black dot starts moving around walking or running and the 3 circles need to move along without touching each other. If anyone touches someone from another circle that person is out."

Speech ostinati by Josh, Elena, Garret and Elias
"The people in the red circle say the whole rhyme. The yellow circle agrees on 3 words of the rhyme and they say it over and over. The blue circle chooses two words and the black dot only says one. They all have to end when the rhyme ends."

The particular group of 4th graders I did this project with is an exceptional class. These examples show how the students are not only thinking about the activity, but they are reflecting some important pedagogical principles of how to perform the activity. Most of the ideas exposed here are, in fact, adaptations of activities these students have learned in their Orff class. Giving them the task of inventing a

game for a younger group of students makes them immediately think about the way we do things with them. This is a powerful learning experience for both the teacher and the students.

A second part of the project consisted of re-thinking the form of the painting by playing with a dot and some rubber bands in an overhead projector. Students created painted variations on the same idea.

Edith, 7 years old

Adrian, 7 years old

Anat, 7 years old

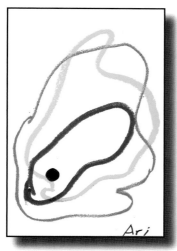

Ari, 7 years old

Bryce, 7 years old

Emma, 7 years old

Isabella, 7 years old

Louie, 8 years old

Lulu, 8 years old

Quincy, 8 years old

Viggo, 8 years old

MIRÓ: "The Gold of the Azure"

Choreographic poem with Fifth grade students

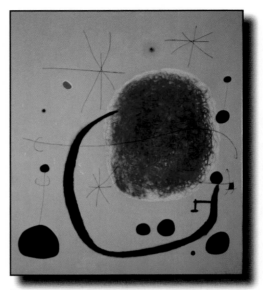

"The Gold of the Azure". Miró (1967)
(Art Resource, NY)

- Students talk about the ideas and elements in the painting.
- Students find ideas to create a movement study.
- They find words and expressions to create a movement poem.
- They start their choreographic work with the first draft of ideas.
- Using a "formula" they create a poem.
- While students choreograph the poem they think about rhythmic variations, repetitions, dynamics etc.

FORMULA POEM

I am (two special characteristics)
I wonder (something you are curious about)
I hear (an imaginary sound)
I see (an imaginary sight)
I want (an actual desire)
I am (the first line of the poem repeated)

Poems by 5th Graders

I am blue steam
I wonder if I am temporary.
I hear cracking stars.
I see dark hunting eyes,
A man like a snake slithers around.
I am blue steam
And I am temporary.

<div align="right">BY JOSH AND ELIZA</div>

Blue Pluto
Floating, flying, sliding.
I wonder why?
I wonder about the objects in the distance.
I hear the empty voice of space,
The sound of popping silence
I see satellites floating by,
Floating debris
Nothing but darkness.
I want to be noticed
I want to be huge
I am Blue Pluto.

<div align="right">BY JACK AND VANESSA</div>

Rocking the blue moon.
Floating left and right
Left and right
And balance, balance, stop.
Thin explosions of black
Crawling spiders.
Rocking the blue moon.
Step and jump
Look!
Rocking and rocking
The blue moon
Sweet, tear of red.

<div align="right">BY LOGAN AND SAM</div>

VAN GOGH "Starry Night"

Seeing, listening and writing poetry

Poetry is like drawing with words. The hand of the writer carefully chooses words to translate feelings, sensations, experiences and ideas for the pleasure of self-expression. Reading and teaching poetry is of crucial importance in education because it helps the students to use and love language.

In this last project, the students draw ideas from a music listening class in which I play a selection of nocturnal music: "The Transfigured Night" by Schoenberg, Chopin's Nocturnes, a "Night Serenade" by Mozart and "The Bioluminesence of the Night" by James Horner (*Avatar*). The students create poems based on their listening experience and visualizing the painting "Starry Night" by Van Gogh.

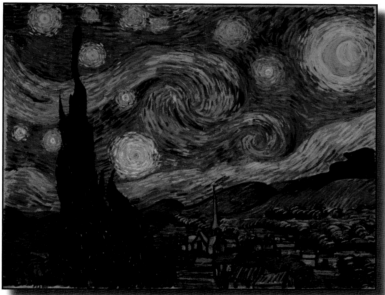

Digital Image © The Museum of Modern Art/Licensed by SCALA / Art Resource, NY

Poems by Seventh graders

Sunlight swirls slowly,
Breaking the diamond veil of the night.
The sun pushes through,
Like a dance across the sky.
Pulsing, stars tremble and wink.
 BY KEALEY

Rolling breeze: strings.
Moon gleaming: cling.
Shadows and hills of grass sweeping
Back and forth.
 BY RICHARD

Light glides swiftly across the sky
Small gusts of wind touch the world.
Beams of light scale the unknown
Night hums.
 BY CASSIDY

Calm, like night.
Echoing mixes with light and whistling gusts of wind.
Flowing flute and creepy ominous noises of darkness
 BY MINH

Like the town,
The quiet horn and flute, drowsing.
Like the stars,
The piccolo like the stars, shinning.
Impression of cloaked darkness,
The calm violin far, far away.
Strings like rolling hills deep and change.
Glittery bells,
Portraying the bright stars.
 BY PAUL

Luz de luna.
Brilla
Como cristales en el silencio.
 BY AMANDA

Estrellas,
Como miles de luciérnagas
Atrapadas en el cielo.
Un ¨bouquet¨ de flores
Violeta, indigo y azul claro
Del rajacielo fino y delgado
Trata de alcanzar la luna que desaparece.
 BY NOA

La luna tiene
Su cara hecha de Manchego y Brie.
 BY ANTONIO

MATISSE JAZZ

The voice of the Blues

The Sword Swallower" Plate XIII of the illustrated book "Jazz" by Henri Matisse.
© 2011 Succession Henri Matisse/Artists Rights Society (ARS), New York.
Digital image © The Museum of Modern Art /Licensed by SCALA/Art Resource, NY.

Henri Matisse-Jazz Lithographs.

The 8th Grade music curriculum at The San Francisco School is dedicated to the study of jazz. These poems are influenced by the yearlong study of this genre with my colleague, Doug Goodkin. The students are not only playing, but also learning the stories of jazz musicians and listening to their music. The assignment here was to write a poem based on looking at the painting while listening to these three pieces:

- "Stand By Me"—Lou Bell Johnson (Wade in the Water): A solo singer "testifying" in church.
- "Have You Ever Been Mistreated?"—Joe Hunter (Blues Masters): A blues with guitar.
- "Resolution"—John Coltrane (A Love Supreme): A saxophone with drums, bass and piano "sings."

Poems by Eighth graders

I am a word
Sprouting out of mouths
Floating through ears
Dancing in minds
I am a piece of a story
Flowing with other words
Other sounds
And I am rooted
Forever
In music's great history.
 BY LOGAN

I am a singer
My voice tells you that you are not alone
My words connect to your feelings.
My song stays the same, but your ears
 change.
I sing out and up so my voice is projected
And then falls back down with gravity and
Lands on the crowd to move them
I don't sing to please
I use my voice to be heard.
I do this to live.
 BY CHELO

I am ecstacy.
A powerful roar that rips out of the chest
I am the sweet taste the drips from the lips
I am a declaration
An ageless mark in history
I am a tree with deep roots
A spring that arrives after an endless win-
 ter.
I am a heartbeat and a breath,
A loving croon and a hateful cry.
 BY LAURA

I am a singer.
The wind blows my notes from my lips
to a listening ear.

I am a singer.
The time passes, but the feelings linger.
I am a singer.
A mind trying to decipher a message
that can't be deciphered.
I am a singer.
Trying to make a difference in
Someone's open mind.
 BY REBECCA

I am a word from the lips of God
I sing a song to release me from the devil's
 smelly feet.
Stand by me, God almighty.
Release me.
 BY IZZY

I am a voice
And I am like river
Changing, but steady
Jumping and fierce in some places,
Shifting and silent in others.
Making it up as I go along.
The sun is falling into me,
Like the spotlight on a stage.
I am ruthless and graceful.
Messy and perfect.
 BY HAILEY

MUSIC LISTENING AND THE VISUAL ARTS

MUSIC LISTENING and the VISUAL ARTS

INTRODUCTION

In this last chapter we explore various ways to prepare students for perceiving music. For the preschool and elementary years, listening activities are usually combined with instrumental and dance activities. For the 7th grade at The San Francisco School, we dedicate some time every week to music listening. My colleague, James Harding, and I lead the students in a process that includes all five senses: we begin with simply hearing something and end by understanding it in a much deeper way. We listen to everything from world music to classical, contemporary and jazz.

Listening to any musical piece is a process wherein the listener can have various levels of involvement, from simply hearing sound to comprehending the musical meaning of the work.

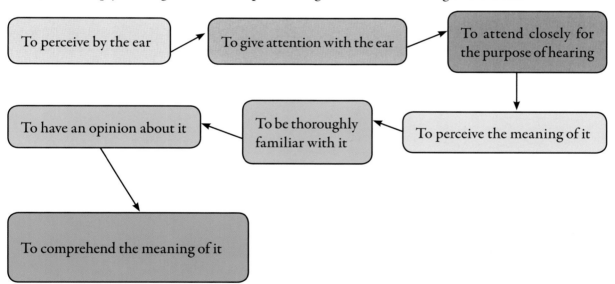

There is a big difference between observing a painting or a sculpture frozen in space and listening to music flowing in time. Standing in front of a painting we can take as long as we want to observe the details and get an impression of the work. Also, when we enter a gallery in a museum we can browse several paintings before choosing one to scrutinize. Imagine attending a piano recital where you could "browse" the music by having the pianist play snippets of each piece before performing the entire work.

In our music listening sessions we browse by highlighting the more exciting parts of the music before playing it in its entirety. We might sing a theme, play a game, show an instrument, perform a rhythm, or dance. Then we listen to the piece, sometimes more than once (we often go back to the same piece after a few weeks). The pieces students like most are usually those they have heard the most. Here are some strategies for leading a discussion:

I HEAR- I THINK -I WONDER	QUESTIONING MUSIC	COMPARING	SITUATING
Lead a group discussion using Project Zero thinking routine.	If you could meet the composer, what questions would you ask about the music?	Thinking about other compositions with similar qualities.	In what kind of building do you think this music should be performed?
I HEAR WITH MY LITTLE EAR	**GETTING INSIDE**	**TITLE**	**WHAT IS IT ABOUT?**
Looking for details, the hidden secrets: instruments, patterns, form, dynamics.	Describe a movie scene that would use music like the kind you are listening to.	Give a title to the piece.	Storyline to the piece.

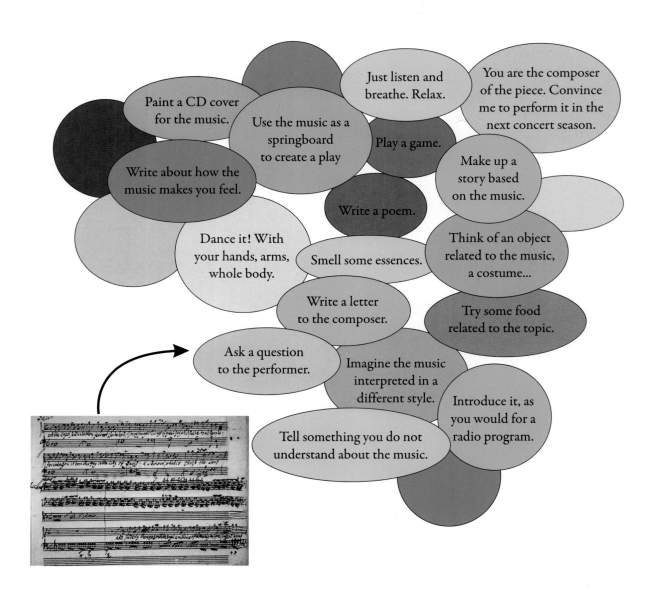

THE CUCKOO IN THE FOREST

"Listening is the key to the musical itinerary of any society. The syllogism that governs this cause-effect relationship is very simple: the music only exists if there is attention."

—Fernando Palacios[*]

Thanathorn

Thanathorn

Most books on music appreciation are overloaded with information, facts of little or no importance about composers, instruments and music trivia. Shops in the concert halls are filled with little Mozart puppets, napkins with treble clefs, tablemats with orchestral instruments and all sorts of paraphernalia to attract the interest of the young children. Although many orchestras have special programs for the young audience in which they talk about concert etiquette and such, the matter of attentive listening is never addressed. Our goal in music appreciation is not to make students the perfect audience, but to get them involved in an active way that stimulates their appetite for discovery.

Here are some basic ideas to keep in mind when preparing students for an active listening experience:

- Start with pieces students will be able to hear outside of class. They will enjoy recognizing the music.
- Create activities that allow students to dance, act, draw, write and connect the music with other arts.
- Tell your students why you like the piece, or some personal story to motivate them.
- Help them notice details.

Many years ago in Spain I brought my students to the Royal Theater to hear the National Symphony perform *The Carnival of the Animals* by Camille Saint-Saens, a suite in fourteen movements composed after he spent a summer on a farm. Each movement is a short, humorous piece inspired by an animal and even though this is one of the most popular pieces for children, I was having a hard time imagining my students sitting through it without losing their attention to the music.

So, I created a listening map to follow the structure of the movement entitled, "The Cuckoo in the Forest," a duet with the clarinet playing an unchanging cuckoo call over a sequence of quiet chords on the piano.

[*] Palacios, Fernando. *Escuchar*. Vitoria-Gasteiz: Agruparte, 1997

LISTENING MAP

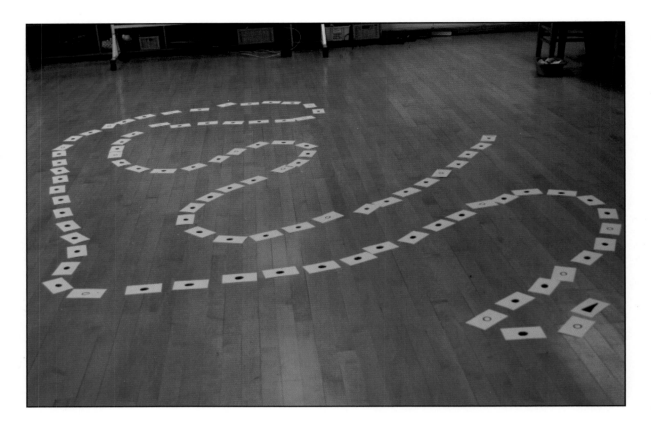

LISTENING MAP

Create 96 cards with the following directions. Number them on the back so that you can organize them quickly.

- All cards have a basic form:

- Cards numbered (5, 10, 21, 27, 33, 37, 43, 45, 49, 51, 54, 57, 70, 81, 87, 90, 93, 95) have an uncolored dot. The students place a play-dough bird they have made earlier on these dots only.

- Card number (21) has a repeat sign:

 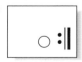

- Card number 96 has a diminuendo sign:

 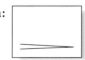

- Lay the cards on the floor in order and ask the students to fill in the empty dots with their birds. Start pointing to the cards following the beat in "The Cuckoo in the Forest" by Saint Saens.

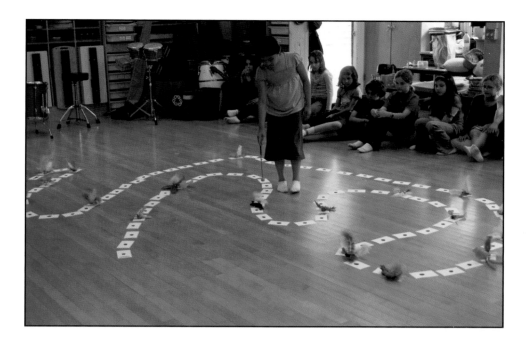

LISTENING

The Cuckoo in the Forest (*Carnival of the Animals* by Saint-Saens)

- Students walk when they hear the piano and stop when they hear the cuckoo.
- Follow the beat on the map and sing along when they point to the cuckoo.

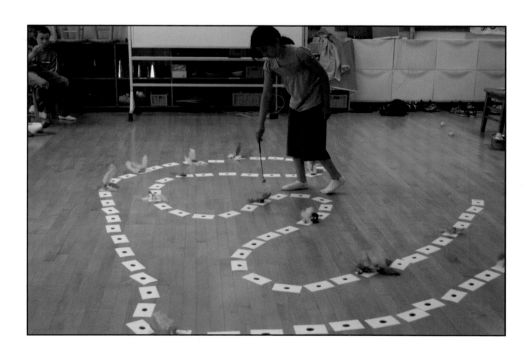

RECORDER

The Cuckoo Song—Germany

Play the cuckoo song and ask the students to fill the gaps (rests) by:

- Clapping, snapping, stamping...
- Playing a short bird call (with whistles or recorders)
- Play the cuckoo call

MOVEMENT (Use the German "Cuckoo Song")

The Cuckoo Song

- The students skip around the room while singing.
- They stop and clap when the cuckoo calls.
- They meet a partner and clap hands together.

THE CUCKOO SONG

German Song
arranged by J. Harding

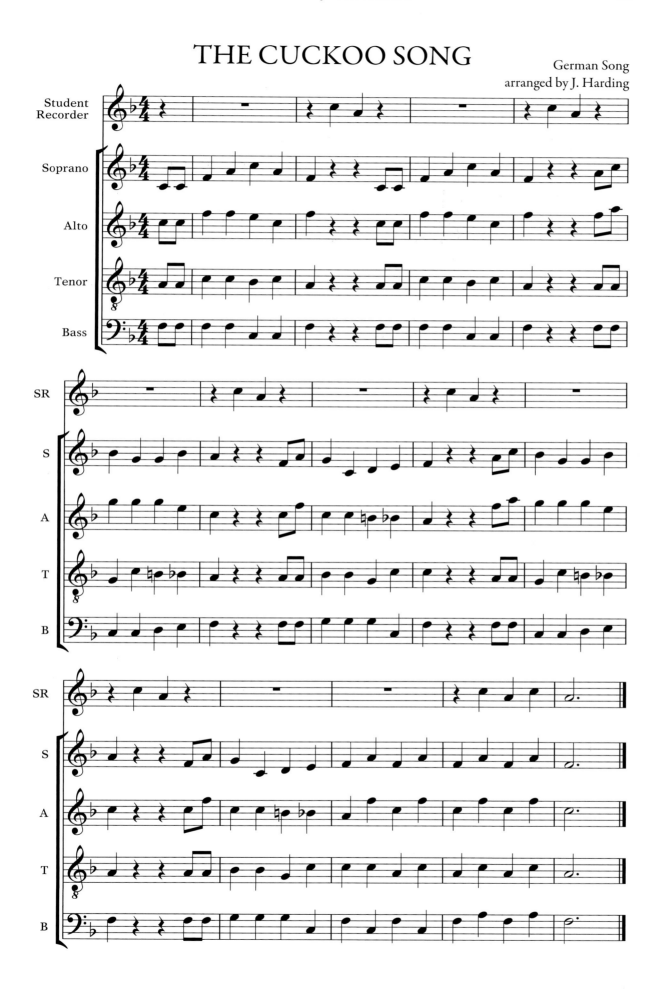

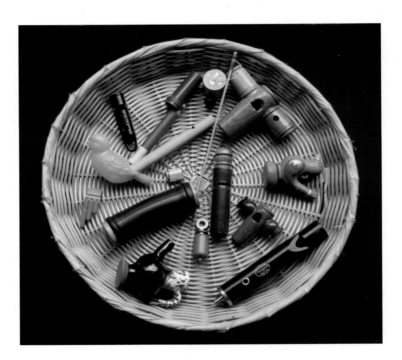

Aiden, 8 years old

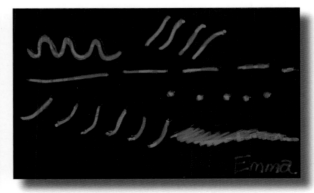

Emma, 8 years old

Brandon, 8 years old

Daro, 8 years old

Liam, 8 years old

THREE DIMENSIONAL BIRD
Make a bird with play-dough and decorate it with feathers of contrasting colors.

LANGUAGE-DRAMA

Create a dramatic or musical skit based on sayings:

- "A bird does not sing because it has an answer. It sings because it has a song."
- "A bird in the hand is worth two in the bush."
- "Birds of a feather flock together."
- "One cuckoo does not make a spring."

Suggested Children's books

De Vos, Philip. Grobler, Piet. *Carnival of the Animals*. South Africa: Front Street. Lemniscaat. 1998

FISHES IN THE SEA

Icke Ockle blue bottle
Fishes in the sea
If you want a partner
Just choose me!

This count-out rhyme from England, exhibits, as do all counting rhymes, a kind of magic that allows us to sort and count without using numbers. These little nonsense poems are found in children's folklore throughout the world and, because they are based on rhythm and sonority, are most often used to point to the players while keeping the beat.

It's fascinating that nowadays, when so many traditional games are disappearing, children still use these rhymes to sort things out: who 's eating the last piece of pizza or who gets the window seat. These rhymes clearly have a past—they come from the days of spontaneous play in the street where kids used them to choose game leaders and to figure out who goes first. Sadly, this is a scene we see less and less of in a play world always monitored and supervised by adults. That's why it's important to encourage children to keep playing them.

In the music class we use counting rhymes to perform tasks such as counting hands or feet in a circle, eliminating the last person and repeating until we have a "survivor." Counting rhymes can also help the children choose an instrument, choose a leader or even the order in which they will lineup to leave the classroom.

This universal form has variations in all languages. Here are some to look up:

Spanish-Retahila	French-Comptine	Portuguese-Lengas Lengas	Italian-Filastroche
German-Reim	Icelandic-Rìm	Finnish-Loppusoinnun	Turkish-Kafiye

This chapter presents another movement from *The Carnival of Animals*, "The Aquarium."

ICKLE OCKLE

Mother Goose
arranged by Sofía López-Ibor

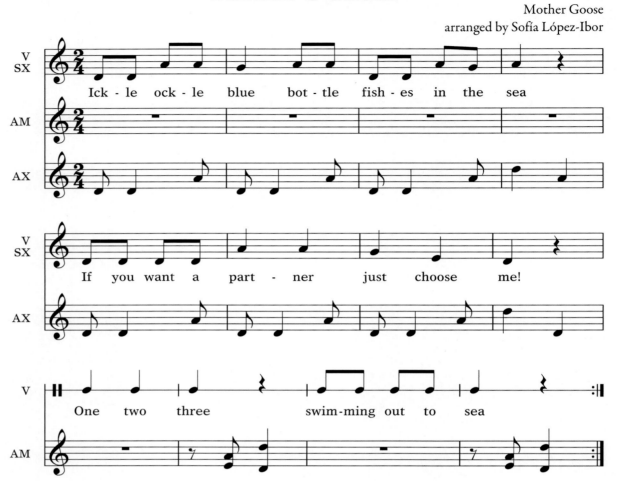

CIRCLE GAME

Ickle Ockle

- Have the students form a standing circle. Choose one student to be the first "fish." While everyone does a pat-clap pattern the "fish" skips inside the circle and at the end of the song chooses a partner. They perform the following gestures together:

 One two three (clap clap clap)

 Swimming out to sea (slide slide slide)

- Then two students start the game and choose another two. Then four choose four, etc.

ORFF ENSEMBLE

Ickle Ockle Pentatonic re mode

Singing and dancing is the most important activity here (accompaniment with xylophone and metallophone are an option for enriching the musical experience).

The piece works very well for beginner recorder players (you can add improvisation parts on xylophones and percussion).

SMALL PERCUSSION

Ickle Ockle

Icke Ockle Blue Bottle
Fishes in the sea
If you want to improvise
Play along with me!

- Use a count-out game to have students choose an instrument one by one. Children play "one two three, swimming out to sea." A variation of the game might be to chant the rhyme while pointing to the participants around the circle. Whoever goes "out" improvises a duet with the teacher.
- Students skip around the room or move while reciting the rhyme and playing a small percussion instrument. Then they meet two by two and improvise a short duet.

MOVEMENT GAME

Octopus

One participant is selected to be the "octopus" and the others are "fish." The "octopus" starts the game sitting in the middle of the floor with the "fish" off to one side. When the "octopus" says: "Swim!" all the fish try to cross to the other side without being tagged. Any fish caught becomes an "octopus" until there are no more fish.

LISTENING MAP
I created this map to help the students follow the melodic lines and musical form of "The Aquarium" by Saint Saens.

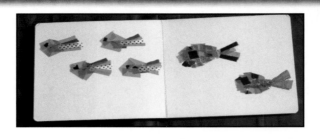

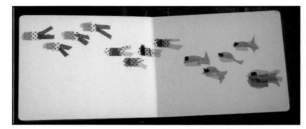

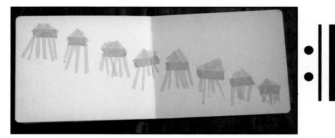

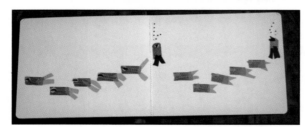

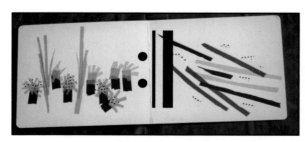

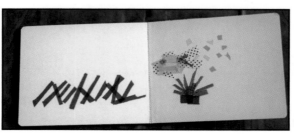

PAPER COLLAGE

This project focuses on positive-negative space. All of the collage sections are ripped, and we try to use every single piece of paper in the process.

- Fold a square of paper in two and rip the shape of half of a fish at the center.
- Open the paper. Glue both positive and negative shapes to paper of contrasting color.
- Cut small squares of origami or similar paper to make the fish scales. Cut a C shape out from them and save the inside part to make the scales.
- Decorate the fish with the scales.

Gordon, 8 years old

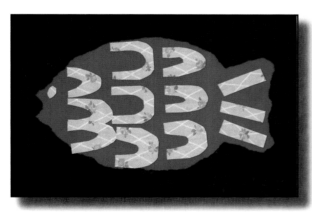
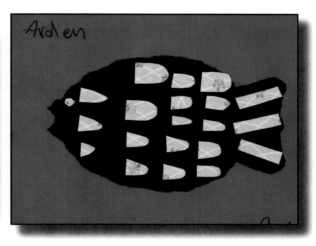

Arden, 8 years old

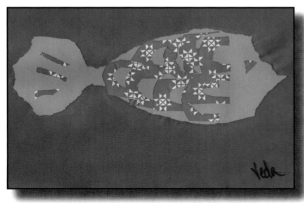
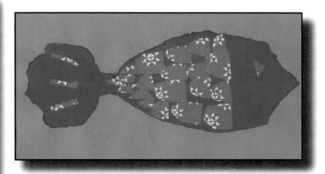

Veda, 8 years old

TESSELATION

- Cut the shape of the fish from a post-it paper to start the tesselatin pattern.
- Color

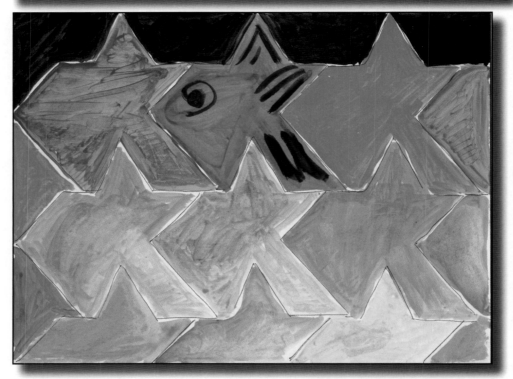

Alvaro, 13 years old

Suggested Children's books

Han, Tae-Hee. *A Fish on the Palm*. Korea: Yearimdang Publishing Co., Ldt. 2005.
Kindersley, Dorling. *Eyewitness Fish*. London: DK. 2005.
Lionni, Leo. *Swimmy*. New York: Alfred A. Knopf. 1963.
Dr. Seuss. *One Fish Two Fish Red Fish Blue Fish*. New York: Random House. 1960.
Pfister, Marcus. *The Rainbow Fish*. USA: North-South Books. 1995.
Rueda, Claudia. *Formas*. Spain: Oceano. 2009.

TRAINS

Surprisingly, trains are still popular in the world of toys, games and music. But the children of the twenty-first century have a very different experience of trains than most songs describe, because today, the fascinating ostinato rhythm and unmistakable "choo choo" whistle can only be heard in transportation museums and amusement parks. Seeing a train passing by is intriguing for the young ones but going on a train ride across the country is a richer event—getting to the station, feeling the train's first movements and watching the landscapes roll by.

One day, while walking down the hall, I saw an exciting display of trains by the kindergarten students that inspired me to develop a musical unit focused on the same topic. I used that as the starting point for exploring movement and improvisation. I also made a collection of recordings of music inspired by trains. Students of all ages improvised and composed pieces based on the paintings by the Kindergartners, based on observations about rhythm, dynamics, texture and timbre. I have also taught this lesson in workshops with teachers around the world and often bring back to the school a recording or video of the adult's performances. The students are always amazed at how their paintings inspire such a variety of music and dance expressions.

The experiences in this project implement the theory of multiple intelligences by Howard Gardner who defines intelligence in a broader way, introducing a variety of abilities and human skills: body-kinesthetic, verbal-linguistic, logical-mathematical, visual-spatial, naturalistic, musical, intrapersonal and interpersonal. We know that children have different ways of understanding things, so we need to create well-rounded lessons that work with the various learning styles. Applying the information the children learn in this lesson to another project (for example, "clocks"), gives us the opportunity to see their understanding of rhythm and tempo. When I'm developing a project for my class, I look for themes that have a wide spectrum of learning possibilities: movement, drama, art, language, science, math and group games. "Trains" is one of those ideal themes in which you can also incorporate history and geography.

"This is what learning is. You suddenly understand something you've understood all your life, but in a new way". (Doris Lessing)

SPEECH

Train of names

Invite the students to make a "train" and when it starts moving, every person says their name as an ostinato.

Sofia Sofia Sofia Sofia Sofia…
Anna Anna Anna Anna Anna…

Vary the timbre and dynamics:
- The train goes through a tunnel.
- There is an earthquake.
- The train is carrying elephants.

TRAIN MARCH

Choose recorded music with a steady beat. Have the students form lines of 6 participants. The first person in the line is the engine and all follow the engine connected by hands to shoulders. Then the teacher plays a drum.
- When teacher plays one beat the engine goes to the back of the train.
- When the teacher plays two or more beats, two or more persons go to the back of the train.

SPEECH AND BODY PERCUSSION

Engine Engine
Engine engine number nine
Going down Chicago Line
If the train stops by the track
Do you want your money back?
Yes. No. Maybe so!
Yes. No. Maybe so!

- Perform with body percussion accompaniment.
- Perform with speech ostinato ("from Chicago")
- Listen to Steve Reich's piece.

ENGINE ENGINE

Nursery Rhyme
arranged by Sofía López-Ibor

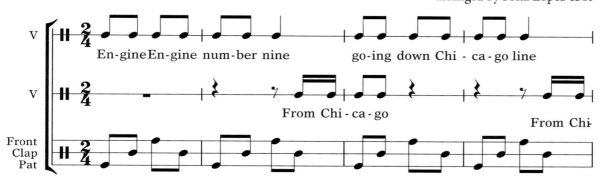

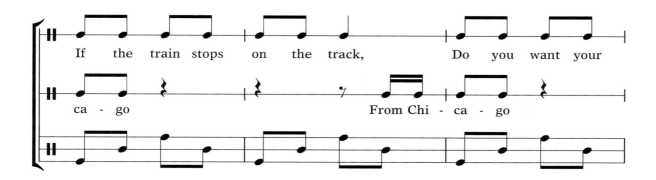

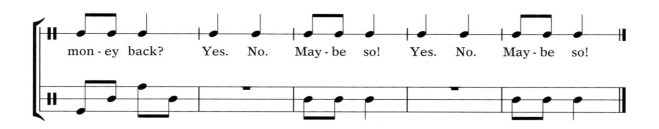

EL TRENCITO

Argentina
arranged by Sofía López-Ibor

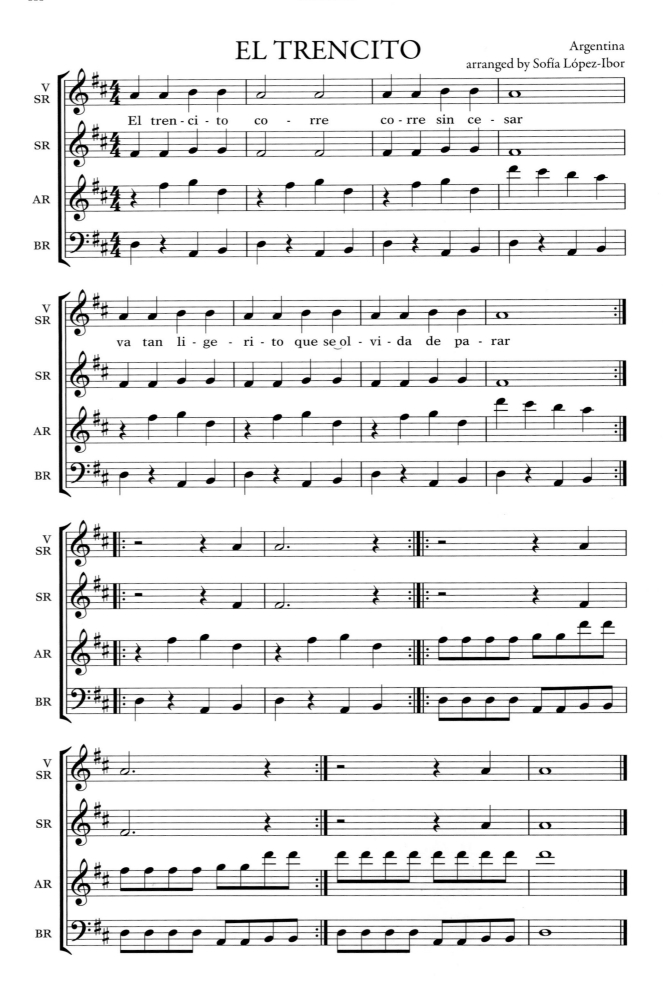

El tren - ci - to co - rre co - rre sin ce - sar

va tan li - ge - ri - to que se ol - vi - da de pa - rar

OIL CRAYONS AND WATERCOLOR

- Give the students a long, rectangular piece of paper. Ask them to paint their favorite geometric shapes in a line:

- Connect the shapes and add other details to complete the train picture.
- The students repeat the project after experiencing the music listening activities and the movement games. Think about how weather, speed, time of day and other issues might affect the final image of your train.

The following trains are made by 5 years old. This is what the young artist's said about each train:

"My train is in the station and ready to leave."

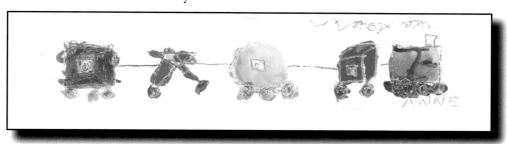

Anne, 5 years old

"My train is in a rainstorm."

Leah, 5 years old

"Inside a tunnel."

Brisa, 5 years old

"You can't see the shapes or the colors when the train is going too fast"

Jack, 5 years old

A train arriving in the station: "The engine has arrived and the wagons are still arriving"

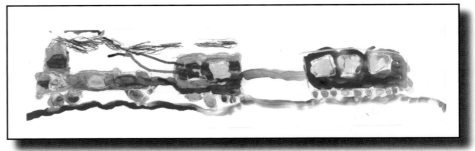

Pablo, 5 years old

"Bumpy train"

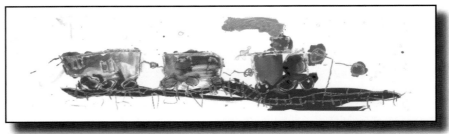

Gordon, 5 years old

"A circus train with animals"

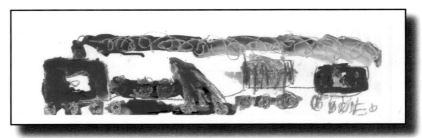

Timothy, 5 years old

"I really like my comfy train!"

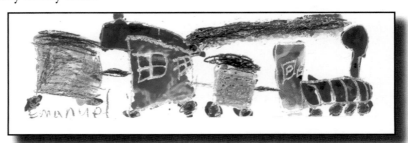

Emanuel, 5 years old

COMPOSITION

Look at the paintings in the art project.

- Ask questions about the kinds of dynamics and tempo the trains might represent.
- Think about the landscape in which they are running (see children's comments next to the picture).
- Choose two different trains of contrasting qualities.
- Create a musical piece that tells the story of those train trips.
- After performing all the pieces, students comment on what they discovered in the music.

Suggested Listening

The Little Train of Caipira (from *Bachiana Brasileira* by H. Villa-Lobos)

The Train (Bobby McFerrin) Medicine Music

Different Trains/America-Before the War (Steve Reich)

Take the "A" Train (Duke Ellington)

Happy-Go-Lucky Local (Duke Ellington)

El Tren Lechero (Eralio Gill) Paraguay

Chattanooga Choo Choo (Glenn Miller)

El Tren (Vieja Trova Santiaguera) Cuba

The Little Red Caboose (Sweet Honey In The Rock)

Pacific 231 (Arthur Honegger)

Suggested Children's Books

Crews, Donald. *Freight Train*. New York: Harper Collins. 1993.

Piper, Watty. *The Little Engine that Could*. New York: Platt & Munk. 1930.

Lenski, Lois. *The Little Train*. New York: Random House. 1940.

Peet, Bill. *The Caboose Who Got Loose*. Boston: Houghton Miffin. 1971.

Kruss, James. Stich, Liesl. *Henriette Bimmelbahn*. Koln: Boje Verlag. 1963.

THE PLANETS

The planets of our solar system fascinate children and tie into many subjects: reading, writing, math, history, geometry, chemistry and art. In music class, it seems obligatory to refer to *The Planets* by Gustav Holst, an orchestral suite that was completed in 1917 and to this day still influences composers of science-fiction movie soundtracks. Holst wrote a movement for each planet but excluded Earth and Pluto. He was thinking about the astrological character of the planets and gave them these subtitles:

- Mars, the Bringer of War
- Venus, the Bringer of Peace
- Mercury, the Winged Messenger
- Jupiter, the Bringer of Jollity
- Saturn, the Bringer of Old Age
- Uranus, the Magician
- Neptune, the Mystic

Here are some ideas for preparing the students to listen to *The Planets*:

- Where do the names of the planets come from?
- Which artists have represented the Roman Gods and Goddesses related to each planet?
- What are the stories of those characters?
- What is the order of the planets in the solar system?
- What are the physical characteristics of each planet?
- Which planets can we see from Earth?
- How does each planet rotate?
- How do planets shine?
- What planet has the shortest year?
- Which planet would be the hottest one to live on?
- Make a list of the colors you would use for each planet according to the characteristics of the Gods that the planets are named after. Compare it with the actual color of each planet.
 Mercury: brown and grey (silicate rock)
 Venus: white (carbon dioxide clouds)
 Mars: red (oxidized rock)
 Jupiter and Saturn: bands of differently colored clouds due to chemical composition.
 Uranus: bluish green (hydrogen, helium, water, ammonia, methane)
 Neptune: blue (hydrogen, helium, methane)

MARS AND VENUS

For the Mars and Venus project sequence the students:

- Perform a speech piece based on the names of the planets.
- Discuss the origin of the names of each planet.
- See a slide show of artwork about Venus and Mars (paintings by Velázquez, Boticelli, Andy Warhol and others and ancient Roman sculptures).
- Gather ideas for comparing the characters of Venus and Mars (see following chart).
- Listen to the movements Mars and Venus from "The Planets" and discuss their musical qualities: dynamics, instrumentation, form, etc.
- Make a pastel painting while listening to the pieces a second time.
- Explore the theme of the planets in music composition and choreography.

Velazquez, Diego Rodriguez The Toilet of Venus ("The Rokeby Venus"),
1647–51
© National Gallery, London / Art Resource, NY

Velazquez, Diego Rodriguez Mars, 1640
Museo del Prado, Madrid, Spain
Photo Credit: Scala / Art Resource, NY

MARS AND VENUS LISTENING ACTIVITY

The Ear	Mars—The Bringer of War	Venus—The Bringer of Peace
1. What instruments would you choose to depict Mars and Venus? 2. What dynamics? 3. Rhythms or structures? 4. Tempo? 5. Musical form? 6. Melody?		

The Body	Mars—The Bringer of War	Venus—The Bringer of Peace
1. Movement 2. Energy and effort 3. Props		

The Eye	Mars—The Bringer of War	Venus—The Bringer of Peace
1. What colors would you choose? 2. What technique? 3. Patterns? Design? 4. Objects?		

Language	Mars—The Bringer of War	Venus—The Bringer of Peace
1. Words, expressions 2. Ideas, feelings, sayings		

Other Senses	Mars—The Bringer of War	Venus—The Bringer of Peace
1. Food 2. Smell 3. Temperature 4. Landscape		

Here are some Seventh grade students' responses to the questions:

THE EAR

WHAT INSTRUMENTS WOULD YOU CHOOSE TO DEPICT...
- **Mars:** Horns, timpani and strings/ cellos and bass/ loud low-pitched instruments/ woodwinds and brass with pulsing strings/ lots of percussion/ slow trombone music
- **Venus:** Flute clarinet and harp/ violins, viola and timpani / panpipes in harmony/ strings for the melody, with flute and clarinet and not much percussion/ high voices singing in harmony/ charming harp

WHAT DYNAMICS?
- **Mars:** Loud and impulsive/ loud at first/ loud with sudden dynamic changes/
- **Venus:** Soft and soothing/ soft legato/ sweeping loud and soft with an unset tempo

RHYTHM OR STRUCTURE?
- **Mars:** Measured, marching/ heroic and slow
- **Venus:** Perhaps a Waltz/ duets

TEMPO?
- **Mars:** Quick and structured/ fast and then slow/ steady quick tempo
- **Venus:** Slower/ steady

MUSICAL FORM?
- **Mars:** Forte throughout-theme after theme
- **Venus:** Start slowly and gradually increasing/ duet

MELODY?
- **Mars:** Powerful and minor/ minor/
- **Venus:** Singing out, soft base/ themes modulate and come back to the original note

THE BODY

MOVEMENT? ENERGY AND EFFORT?
- **Mars:** Punch, run, jump fast/ sudden changes of impulsive energy/ violent, sudden
- **Venus:** Flowing legato/ float, flow, slide, slow motion

PROPS
- **Mars:** Sticks/ swords/ spears
- **Venus:** Feathers/ scarves/ flowers/ shells/ water bows/ fabric

THE EYE

WHAT COLORS WOULD YOU CHOOSE?
- **Mars:** Scarlet, black and silver/ red, yellow and dark orange/ harsh reds and orange
- **Venus:** Yellow, pink and blue/ white, light blue and black/ muted watery colors

WHAT TECHNIQUE (PAINTING)?

- **Mars:** Jagged lines, sharp/ loose hand/ zig-zag/ black deep paint splotches/
- **Venus:** Curves, fluid/ soft long hand movements/ sweeps of calm feeling/ watercolor/ light swirls

PATTERNS? DESIGN?

- **Mars:** Fire! / no pattern, no designs, very loose/ long strokes of color "lava-like" and explosions
- **Venus:** Blending waves/ curves/ water-like/ spheres

OBJECTS?

- **Mars:** Shield, armor
- **Venus:** Jewelry, flowers

LANGUAGE

WORDS, EXPRESSIONS, FEELINGS, SAYINGS, IDEAS

- **Mars:** Sharp, painful, strong warrior / strong mighty/ harsh mean ideas/ scary and intimidating/ terrifying fear/
- **Venus:** Love, beautiful, feminine, slightly shallow /powerful, but gentle/ laughter of innocence/ love story/ caring and calm/

OTHER SENSES

FOOD

- **Mars:** Lobster!/ buffalo steak/ spicy food with tender meat/ steak on the grill
- **Venus:** Maple syrup / Caesar salad/ soft pasta with garlic bread and wine/ grapes/ risotto with vegetables/ vanilla ice cream/ comfort food/ rice

SMELL

- **Mars:** Smoky/ strong smell/ oily
- **Venus:** Floral /light smell/ perfume/ apple / rose petals/ lavender

TEMPERATURE

- **Mars:** Hot/ burning hot
- **Venus:** Misty/ fresh

LANDSCAPE

- **Mars:** dry dessert/ volcano
- **Venus:** garden/ landscape with beautiful plants/ green grass wide-open space

Most of the pieces we study in the music listening lesson are posted in our homework website for middle school. The students have the opportunity to listen again to the piece at home and share some ideas with their parents. One of our students who loves composing got inspired and wrote an orchestral movement titled *Mars-God of War* for oboe, clarinet, bassoon, trumpet, tuba, timpani, cymbals, side drum, glockenspiel, violin, violoncello and double bass. Later we made a score reduction and selected Paul's theme to be performed by the Orff Ensemble with other episodes written by the rest of the students in the class.

MARS AEOLIAN THEME

Sofía López-Ibor

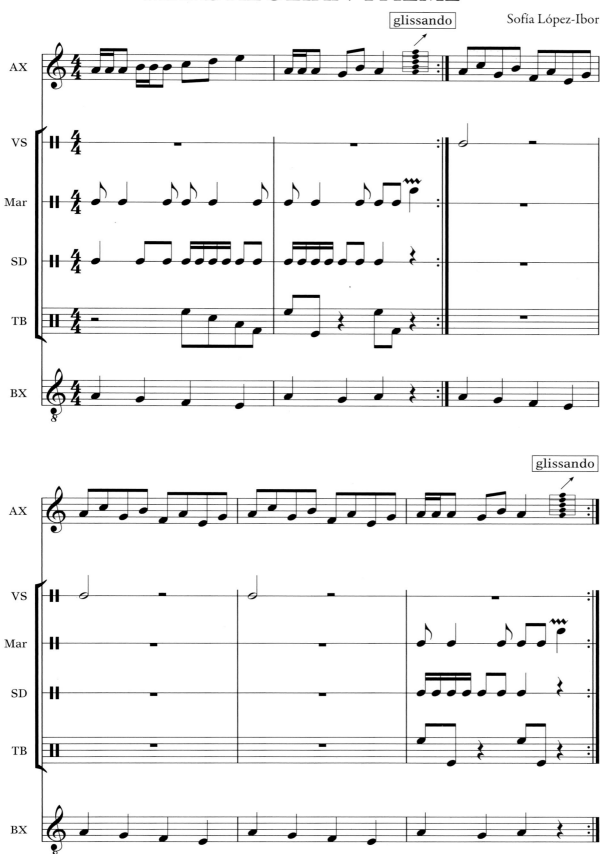

VENUS THEME

Sofía López-Ibor

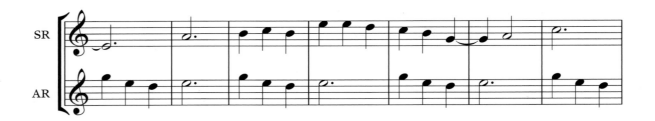

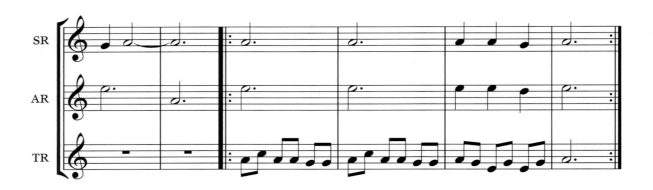

PASTELS

Make a chalk pastel about Mars and Venus that reflects your pattern, color and motive selection in the music listening activity.

Tucker, 13 years old

Ben, 13 years old

Jasmine, 13 years old

Brendan, 13 years old

Peter, 13 years old

Suggested Children's Books

Hasbrouch, Ellen. Planets. *A Solar System Stickerbook*. New York, London. Toronto: Little Simon. 2001.

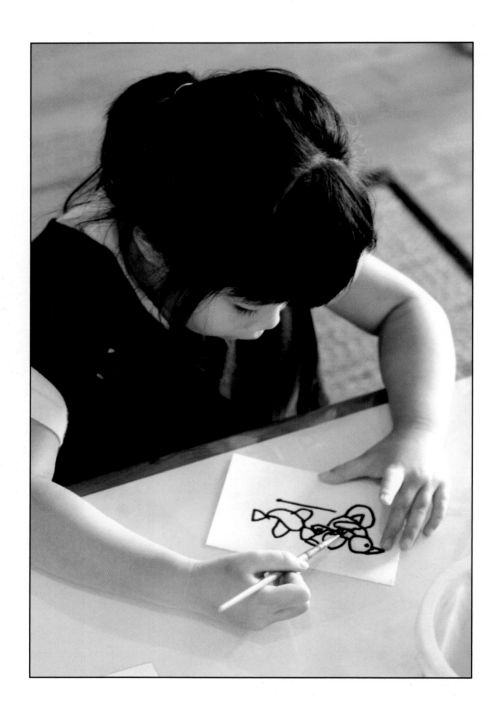

EPILOGUE

I write the last page of this book at the turn of a new school year. My teaching room is organized, the instruments repaired and the mallets sorted. Clay, blank paper and new brushes fill the desk drawers. I am filled with beautiful memories of last year's classes with the children, reflected in the photos and artwork in the book. I am committed again to provoke meaningful learning by combining the arts in the classroom and understanding the relations, similarities and differences between all expressive forms. I'm looking forward to what surprises the children have in store for me this year, what heart-stopping moments I'll witness as they play, sing, dance, draw and think their way through my classes.

As the new school year starts, most of the art pieces in this book have been returned to their creators. They hang in children's rooms, kitchen refrigerators or sleep in a drawer somewhere. But one of them stays with me. It is a butterfly collage, small little pieces of colored paper glued with starch on a canvas. It was made by Alba, one of the children struggling with cancer in the Madrid hospital. I guided the girl painting the symmetrical shaped insect and she combined the colors wisely to fill in the wings. I remember how intent she was while working, how happy she looked when she finished.

Alba became a butterfly of the spirit. She still sings, laughs and whispers in my ear of the power of art. Every time I look at this collage, I will remember her strong beautiful spirit.

The arts bring us joy and the chance to tell the world who we are. That is why we, teachers of the arts, need to dedicate ourselves to doing this work well. That's why I wrote this book.

The butterfly counts not months but moments, and has time enough.
—RABINDRANATH TAGORE

Alba, 14 years old

INSTRUMENTS AND ABBREVIATIONS

V	Voice
SR	Soprano Recorder
AR	Alto Recorder
TR	Tenor Recorder
BR	Bass Recorder
SG	Soprano Glockenspiel
AG	Alto Glockenspiel
SX	Soprano Xylophone
AX	Alto Xylophone
BX	Bass Xylophone
BB	Bass Bars
SM	Soprano Metallophone
AM	Alto Metallophone
BM	Bass Metallophone
CB	Cowbell
Tamb.	Tambourine
Tr.	Triangle
Gl.	Glasses
W.Ch.	Wind Chime
WB	Woodblock
VS	Vibraslap
Sh.	Shaker
Gui.	Guiro
Mar.	Maracas
Cl.	Claves
Ld	Log Drum
Cab.	Cabassa
TB	Temple Blocks
HD	Hand Drum
Con.	Conga
Bon.	Bongo
Gtr	Guitar

BIBLIOGRAPHY AND DISCOGRAPHY

PEDAGOGY

Palmer, Joy A. *Fifty Major Thinkers on Education*. USA: Routledge, 2001.

Montessori, Maria. *Dr. Montessori's Own Book*. New York: Dover, 2005.

Jensen, Eric. *Arts with the Brain in Mind*. Association for Supervision and Curriculum Development. Alexandria, Virginia. 2001. Pag. 12

Castle, E.B. *Ancient Education and Today*. England: Penguin Books, 1961.

Jagla, Virginia M. *Teacher's Everyday Use of Imagination and Intuition*. New York: State University Press. 1994.

Goodkin, Doug. *The A B C'S of Education, A Primer for Schools to Come*. San Francisco: Pentatonic Press. 2006.

MUSIC AND DANCE:

Frazee, Jane. *Orff Schulwerk Today*. USA: Schott. 2006.

Goodkin, Doug. *Play, Sing and Dance. An Introduction to Orff Schulwerk*. USA: 2002.

Goodkin, Doug. *Intery Mintery*. San Francisco: Pentatonic Press. 2009.

Haselbach, Barbara. *Dance Education: Baric Principles and Models for Nursery and Primary School*. New York. Schott. 1979.

Haselbach, Barbara. *Improvisation, Dance, Movement*. Klett. 1981

Haselback, Barbara. *Tanz und bildende Kunst. Modelle zur Ästhetischen Erziehung*. Klett. 1991

Humphrey, Doris. *The Art of Making Dances*. New York: Grove Press, 1959.

Orff, Carl. *The Schulwerk: Its Origins and Aims*. Translated by Arnold Walter. Music Educators Journal, Vol.49, No.5 (Apr.-May, 1963), pp. 67-74. MENC: The National Association for Music Education. 1963.

Palacios, Fernando. *Escuchar*. Vitoria-Gasteiz: Agruparte, 1997.

Preston-Dunlap, Valerie. *Dance in Education*. London and New York: Longman, 1980.

Sauer, Theresa. *Notations 21*. New York: Mark Batty Publisher, 2009.

CHILDREN'S RHYMES AND POETRY

Opie, Iona and Peter. *The Oxford Dictionary of Nursery Rhymes*. England: Oxford University Press. 1951.

Opie, Iona and Peter. *The Lore and Language of Schoolchildren*. England: Oxford University Press. 1959.

Opie, Iona and Peter. *Children's Games in Street and Playground*. England: Oxford University Press. 1969.

ART

Arment, David. Flick-Jordaan, Marisa. *Contemporary Zulu Telephone Wire Baskets*. Santa Fe: S/C Editions, 2004.

Baran, Miriam. Martin, Gilles. *Butterflies of the World*. New York: Abrams, 2006.

Bohm-Duchen, Monica. Cook, Janet. *Understanding Modern Art*. USA: EDC Publishing, 1988.

Blizzard, Gladys S. *Come Look With Me. World of Play*. USA: Charlesbridge Publishing. 2006.

Carroll, Colleen. *How Artists See Play*. New York: Abbeville Publishing Group. 1999.

Cressy, Judith. *A Treasury of Children's Songs*. The Metropolitan Museum of Art. New York: Henry Holt and Company. 2003.

Cressy, Judith. *Can You Find it Too?*. New York: The Metropolitan Museum of Art. Harry N. Abrahms, INC., Publishers. 2004.

Delpech, Sylvie. Leclerc, Caroline. *Alexander Calder*. Paris: Editions Pallete. 2007

Downer, Marion. *Children in the World's Art*. New York: Lothrop, Lee & Shepard Company. 1970.

Fletcher, Alan. *The Art Book for Children 2*. New York: Phaidon. 2007.

Haddad, Helen R. *Potato Printing*. New York: Thomas Y. Crowell. 1981.

Hoban, Tana. *Look Again*. USA: Macmillan Publishing, 1971.

Keightley, Moy. *Investigating Art. A Practical Guide for Young People*. Great Britain: Bell & Hyman Limited. 1976

Klee, Paul. *On Modern Art*. London: Faber and Faber Limited. 1948.

Klee, Paul. *Pedagogical Sketchbook*. London: Faber Edition. 1953.

Luxbacher, Irene. *1 2 3 I Can Make Prints!* Canada: Kids Can Press. 2008.

Luxbacher, Irene. *The Jumbo Book of Art*. Canada: Kids Can Press Ldt, 2003.

Martin, Laura C. Cain, David. *Nature's Art Box*. United States: Storey Books, 2003.

McDonnell, Patrick. *Art*. New York: Little, Brown and Company. 2006

Micklethwait, Lucy. *A Child's book of Play in Art*. New York: DK Publishing, INC, 1996

Munari, Bruno. Art *Theoremes*. Italy : Scheiwiller. 1961.

Munari, Bruno. *Drawing the Sun*. Verona: Edizioni Corraini. 1980.

Munari, Bruno. *Design as Art*. England: Penguin Books. 1971.

Noelani Wrigth, Jessica. *Come Look With Me. Exploring Moden Art* . USA: Bank Street College. Charlesbridge Publishing. 2006.

Perkins, David N. *The Intelligent Eye. Learning to Think by Looking at Art*. USA: Getty Publications. 1994.

Polland, Barbara Kay. *The Sensible Book. A Celebration of Your Five Senses*. Berkeley: Tricycle Press. 1974

Presilla, Maricel E. Mola. Cuna *Life Stories and Art*. New York: Henry Holt and Company. 1996.

Roalf, Peggy. *Looking at Paintings. Children*. New York: Hyperion Books for Children. 1993.

Shoeser, Mary. *World Textiles. A Concise History*. London: Thames & Hudson World of Art, 2003.

Schuman, Jo Miles. *Art from Many Lands, Multicultural Art Projects*. Massachusetts: Davis. 2002.

Schulte, Jessica. *Can You Find it Outside*. New York: The Metropolitan Museum of Art. Abrams Books. 2005.

Schulte, Jessica. *Can You Find it Inside*. New York: The Metropolitan Museum of Art. Abrams Books. 2005.

Yenawine, Philip. *Lines, Colors, Shapes, Stories*. New York: Museum of Modern Art, Delacorte Press. 1991.

REFERENCE

Michener, Charles D. *The Bees of the World*. Baltimore, Maryland: John's Hopkins University Press, 2000.

Elliot, Lang. *Music of the Birds. A Celebration of Bird Song*. Boston/ New York: Houghton Mifflin Company, 1999

Beardsley, John. Arnett, William. Arnett, Paul. Livingston, Jane. *The Quilts of Gee's Bend*. Atlanta: Tinwood Books. 2002.

WEBSITES

Sandved, Kjell Block. "The Butterfly Alphabet". http://www.butterflyalphabet.com/ (October 22, 2009).

WFMU's Beware of the Blog. Graphic Notation

Ashwal, Gary. Malsbury, Evan. Chung, Soojin. Prajapati, Sheetal. Feldman. Pictures of Music. http://www.blockmuseum.northwestern.edu/picturesofmusic/ (September 30, 2009. October 12, 2009)

MUSIC CD's

Rimsky Korsakov, Nicolai. *The Flight of the Bumblebee*. Yo Yo Ma and Bobby McFerrin. Hush. 1992. Sony

Villa-Lobos, Heitor. *Bachianas Brasileras*. Andrew Mogrelia, Kennethe Schermerhorn, Nashville Symphony. 2005. Naxos

Copland, Aaron/ Ibert, Jacques/ Dvorak, Antonin/ Villa-Lobos, Heitor, Honegger, Arthur & others. *Railroad Rhythms: Classical Music about Trains*. Stuttgart Radio Symphony Orchestra. SWR Music

Holst, Gustav. *The Planets*. Charles Dutroit and Montreal Symphony Orchestra. DECCA

Horner, James. *Avatar* original soundtrack. 2009

Rimsky Korsakov, Nicolai. *The Flight of the Bumblebee* from *The Tale of Tsar Sultan*. Naxos. 8554236

Strauss. *Pizzicatto Polka*. Naxos 8554466-67

Saint-Saens, Camille. *The Carnival of the Animals*. London Sinfonietta, Cristina Ortiz and Pascal Roge. DECCA

Saint-Saens, Camille. *The Carnival of the Animals*. The King's Singers. EMI

DANCE CD'S

Tänze für Kinder und Jugendliche- CD 51054. Switzerland: Swiss Pan

Tänze für Kinder- CD 4415. Germany: Fidula Verlag. A-5033 Salzburg

Tanzen in der Grundschule- 4424. Germany: Fidula Verlag. A-5033 Salzburg

Childrens Dances of Terra Del Zur. The Best of Shenanigans Dance Music. Vol. 1. Australia: Shenanigans.

Bush *Dances of New Holland. The Best of Shenanigans Dance Music*. Vol. 2. Australia: Shenanigans.

Folk Dances of Terra Australis. The Best of Shenanigans Dance Music. Vol. 3. Australia: Shenanigans.

Chimes of Dunkirk- Great Dances for Children. Usa: New England Masters Production.

Danses d' Europe 1- U 310010. France: Unidisc

Danses d' Europe 2- U 310011. France: Unidisc

Danses du Monde- U 310012. France: Unidisc

ABOUT THE AUTHOR

Sofía López-Ibor has taught music for the past 29 years. She studied Music Pedagogy in Madrid (Spain) and at The Orff Institute of the University Mozarteum in Salzburg (Austria) and has presented workshops all over the world. She teaches Level 1 in The San Francisco Orff Certification Course as well as Music Didactics in the Special Course at The Orff Institute. She organizes International Summer Courses in Spain and during the year she teaches at The San Francisco School, where she has worked with children from three-years old to eighth grade since 1996. She is the co-author of the book *Quien Canta su Mal Espanta* (Schott Music Corp.), a collection of songs and dances from Latin-America.

ABOUT PENTATONIC PRESS

Pentatonic Press was formed by Doug Goodkin in 2004 with the following goals:

- To further the development of Orff Schulwerk through quality materials, ideas and processes grown from work with children of all ages.
- To attend to the roots of quality music education while exploring new territory.
- To provide a model of music and dance at the center of school curriculums, revealing their inherent connection with all subjects and their ability to cultivate community.
- To use music as a vehicle to reveal and cultivate each child's remarkable potential as an artist, citizen and compassionate human being.
- To offer full artistic control over the presentation of published material.

Pentatonic Press's growing catalogue includes five published books and two CD's.

Upcoming projects include such diverse subjects as guidelines for effective teaching, drama and nursery rhymes, Ghanaian xylophone music, Ghanaian children's games, Indian music for children, jazz piano for all, intermediate jazz for Orff ensembles, pentatonic, modal and harmonic music from the world repertoire for children of all ages, a collection of songs for all occasions and more. For further information go to www.douggoodkin.com.